IMAGES

of America

JACKSON

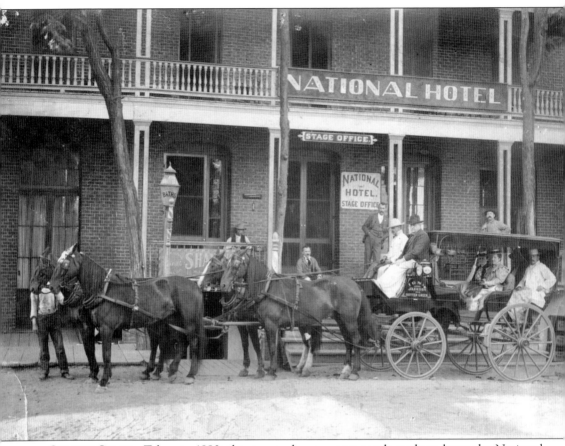

ON THE COVER: Taken in 1880, this image shows a stagecoach ready to leave the National Hotel. The building has stood at the south end of Jackson's Main Street since 1863. It was built after a fire destroyed the Louisiana House, the first hotel constructed on the site. The National is a landmark in town and still provides rooms, meals, and entertainment to guests. (Courtesy Amador County Archives.)

IMAGES
of America

JACKSON

Deborah Coleen Cook

ARCADIA
PUBLISHING

Published by Arcadia Publishing
Charleston SC, Chicago IL, Portsmouth NH, San Francisco CA

Printed in the United States of America

Library of Congress Catalog Card Number: 2006938514

For all general information contact Arcadia Publishing at:
Telephone 843-853-2070
Fax 843-853-0044
E-mail sales@arcadiapublishing.com
For customer service and orders:
Toll-Free 1-888-313-2665

Visit us on the Internet at www.arcadiapublishing.com

This book is dedicated to my parents, who taught me the wonder of learning; my brothers, who are my lifelong heroes; my daughters, who now teach me; my grandchildren, who are my constant delight; and my husband, who patiently put up with the endless piles of paper and books. To all of you, you are my light in this life.

CONTENTS

ACKNOWLEDGMENTS

This book began as the work of the author but ended up as the work of many. I am deeply grateful to many people who came before me in researching many of the buildings, residents, and history of the town. Local historians, authors, and descendants of Jackson's pioneer families, too numerous to name here, have all contributed to this work. I would especially like to thank Judith Marvin and Larry Cenotto for their comprehensive work on the historic-building survey of Jackson, and Larry for his tireless gathering of the history that proved invaluable in the preparation of this publication. My gratitude also goes out to local author Eric Costa. His writings on the history of the Amador County grape industry are an indispensable research tool.

I also thank the County of Amador for the use of their collection of historic photographs and their continuing support in the preservation of the rich history of Amador County.

Finally, I would like to thank John Poultney, my editor, for his support and help along the way. Without him this book would not be possible.

INTRODUCTION

When one first sets eyes on Jackson, he or she cannot help but notice the distinct geographic setting of this small town. It is nestled in the cradle of a small valley backed by the silhouette of the extinct, volcanic Butte Mountain. A stroll down Main Street amidst the tall wood and brick structures takes the visitor back in time to the era of California's gold rush. A drive through the surrounding neighborhoods offers a glimpse into the lives of the residents. At the top of courthouse hill, one can see off into the distance in all directions. To see Jackson, whether in person or through the pages of this book, is a memorable experience.

Jackson was borne of gold, grew with gold, and became a gem. As with numerous other small towns nestled in foothills of the Sierra Nevada, the town has experienced boom and bust and yet endures. Prior to the arrival of men seeking fortunes in the goldfields, the area was occupied by native populations. For thousands of years, the Sierra Mi-wuk called this place home. It is probable that after the arrival of the Spanish in California there was some interaction between the two groups; however, it was not until the gold rush that large numbers of newcomers displaced the native peoples from their land. Gold seekers from around the world settled in and around Jackson, building a community with a diverse ethnic population. Many worked in the mines, some provided goods and services, and still others became farmers and ranchers. A number of mines were opened up at Jackson, with the Kennedy and Argonaut developing into two of the largest producing mines in the world. Agriculture thrived with the cultivation of fruit trees and grape vines and the raising of livestock. Today the community continues to support a successful wine industry. As the town progressed through the 20th century, the mines were closed down, resulting in an economic slump in the region. The economy soon rebounded when the mining was replaced by local industry and retail business. In addition, the town has become a favorite destination for tourists. In recent years, the population of Jackson and surrounding rural areas has grown. Many families seeking the "small-town life" have relocated from larger cities.

There has not yet been a concise history written of Jackson, California. Numerous publications have addressed various aspects of the town's past including, Mason's 1881 *History of Amador County*, Cenotto's four-volume series of *Logan's Alley*, and the *Amador County History*, published in 1927 by the Amador County Federation of Women's Clubs. Likewise, publications of special interest cover specific topics within the history of the town. The recent publication of *47 Down* by Henry Mace provides a detailed narrative of the Argonaut Mine disaster, which sent shock waves around the world when 47 of Amador's miners died in a disastrous fire. *Nothing Left to Commemorate: The Story of the Pioneer Jews of Jackson* by Harold Sharfman (1969) presents a superb history of the no-longer-extant Jewish community. In addition, many publications concerned with the California gold rush offer information on Jackson and its early residents.

This book is not intended to be a history of Jackson, although from beginning to end it is laid out so as to take the reader on a journey from the town's beginnings into the present. The images presented herein are intended to acquaint the reader with the history of the town and provide a window into the present community, to introduce some of the people who have lived and still live here, and to show the dynamics of a small town in an encapsulated form.

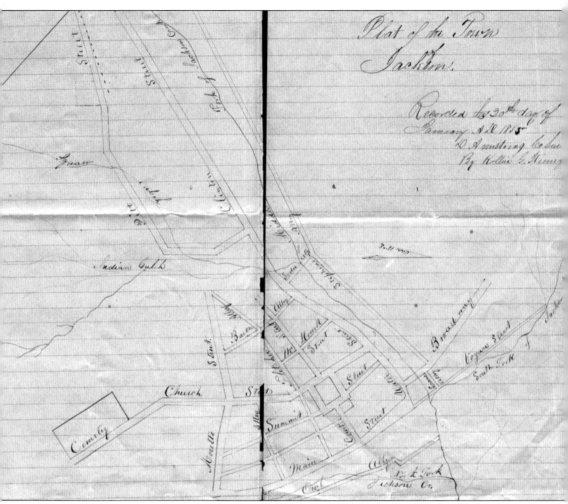

Benjamin Ross drew this plat map of town of Jackson in 1855. Just seven years after the first permanent settler set up here, the town already had a well–laid out system of streets and quite a large cemetery plot. Gold was first discovered at the forks of the creek just below Vogan Street. (Courtesy Amador County Archives.)

One

In the Beginning
Jackson's Early Years

Jackson had its beginnings, as did many other early gold-rush towns, at a gradual pace. Jesse D. Mason in his *History of Amador County* states that this place, at the forks of Jackson Creek, was first known as Bottellas, named for the large number of bottles left at a spring where the National Hotel now stands. The spring was a stopping place for persons traveling between Drytown and the Mokelumne River. The first permanent settler at the future town site, Louis Tellier, arrived some time before 1850. The reader will learn more of Tellier in this chapter. He was soon followed by a number of others, miners and businessmen seeking their fortune in a virgin land. By August 1850, there were seven permanent buildings in Jackson, and by December of that year, the population had reached 100 people. While the miners found wealth panning the gold from the creeks, others soon discovered that the miners needed merchandise, and thus many businesses were established. Hotels, saloons, mercantiles, blacksmiths, clothiers, and doctors set up all along Main, Water, and Broadway Streets. In 1854, Amador County was formed from portions of Eldorado and Calaveras Counties, and Jackson was established as the county seat. By 1860, it was a thriving business center and served as a crossroads stop for the stage lines between the mining towns up and down the Mother Lode. Despite the prosperous growth of Jackson, the town suffered several ups and downs during its early years. In December 1861, the town was flooded when Jackson Creek overran its banks and swept away 20 buildings. The following August, a devastating fire destroyed all the buildings in town, with the exception of three or four brick structures on Main Street and several residences at the edge of the settlement. In 1878, another flood occurred in Jackson, once again sweeping away many buildings, including the entirety of Chinatown, which was situated at the north end of town. The settlement was rebuilt after each of these disasters and continued to flourish as a center of commerce and mining, as it is still today.

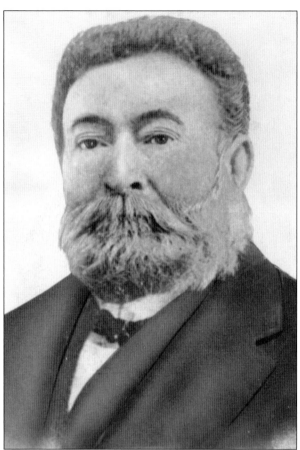

It is believed that Jackson was named for Col. Alden A. M. Jackson, a Mexican War veteran who visited the future town site in 1848 with a group of prospectors. Jackson moved on to found the town of Jacksonville in Tuolumne County. Interestingly enough, he was a close friend to Pio Pico, the former Mexican governor to California. Pio was the brother of Andreas Pico, who fought with settlers over the Arroyo Seco land grant near Ione in Amador County. (Courtesy Amador County Archives.)

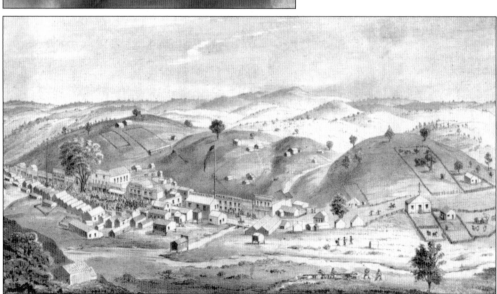

In the spring of 1854, Charles Parish, an architect and artist, drew this view of Jackson. Note the large crowd surrounding the "hanging tree" at the center of town. The reader will find more on the tree and its victims in Chapter Two. (Courtesy Amador County Archives.)

Louis Tellier, a native of France, is credited with being the first permanent settler at the site that would become Jackson. He arrived at the forks of Jackson Creek around 1848, where he constructed a house of logs and rawhides. Several early travelers' accounts of 1848 and 1849 tell of a "Frenchman's hut" and a "French restaurant at Jackson," both of which may have been Tellier. By 1850, he was in the saloon business, his being one of seven buildings in Jackson at that time. In 1865, he married Rosalie Schwartz, a widow, also a native of France. Tellier was instrumental in having the trail from Jackson to Sacramento via Buena Vista cut wide enough to accommodate wagon travel. Tellier operated his saloon until his death in February 1882. (Courtesy Amador County Archives.)

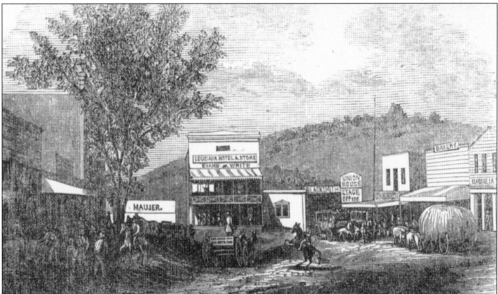

This c. 1855 lithograph of Jackson is one of the earliest depictions of the town. At center of the image is the Louisiana House, built by D. C. White and Ellis Evans. The building to the left of the hotel was the establishment of Amos Maujer and Daniel Barrett. The first Wells Fargo office in Jackson was in this building, with Barrett serving as the first agent. This wooden structure was replaced with a brick building in 1855. To the west of the Louisiana House is the blacksmith shop of Louis Martell and Thomas D. Wells. Next to this is the Union House, operated by Sloan and Stevenson. All of the buildings depicted here were destroyed by fire on August 23, 1862, with the exception of Barrett's brick structure. Also pictured is the famous "hanging tree" of Jackson. (Courtesy Amador County Archives.)

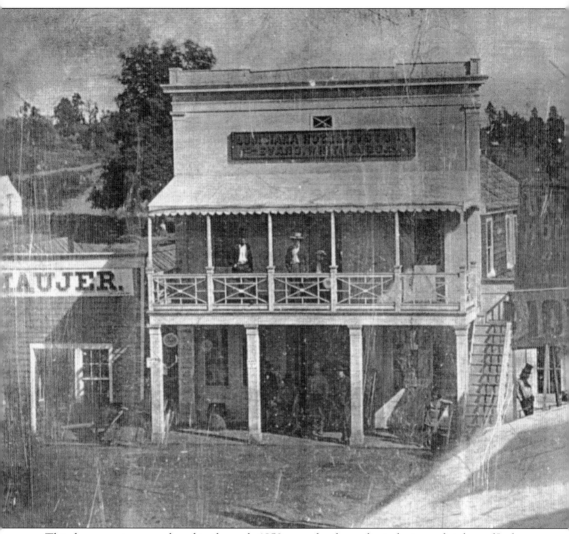

This daguerreotype, produced in the early 1850s, may be the earliest photograph taken of Jackson. Pictured here are the Louisiana Hotel and portions of the establishment of Barrett and Maujer and the Union House. The Louisiana House was constructed in 1852 by D. C. White and Ellis Evans. Armstrong Askey, Evans's cousin, later bought into the business. (Courtesy Amador County Archives.)

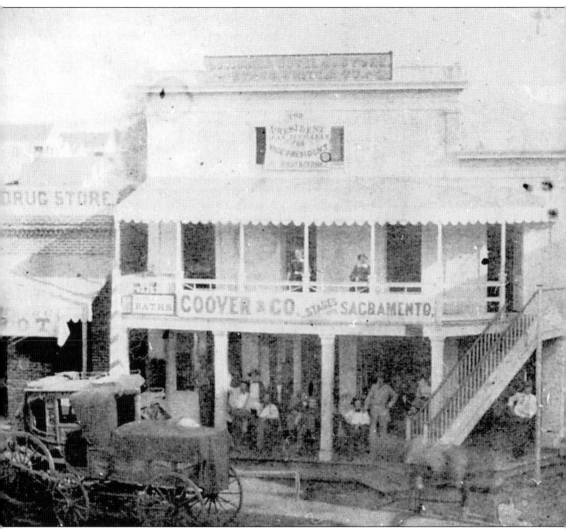

This later photograph of the Louisiana House was taken in 1856 by D. H. Woods, who at the time was rooming at the hotel. Note the changes that have taken place—the wooden building that housed Barrett and Maujer's store has been replaced by a brick structure, and a more substantial staircase has been added to the hotel for access to the second floor. The sign over the entrance announces the establishment as a stop for Charles Coover's stage lines operating out of Sacramento. Coover ran his stage route between Volcano and Sacramento through Jackson and Drytown. This building was destroyed on August 23, 1862, when a devastating fire swept through the town, burning all but the brick buildings to the ground. The partners rebuilt a larger hotel after the fire, naming the new establishment the National Hotel, which remains to this date. (Courtesy Amador County Archives.)

Armstrong Askey was one of the first businessmen in Jackson. Askey came to California in the fall of 1850 and first settled at Volcano. He then engaged in mining in Butte Basin, where he made enough money to partner with D. C. White in the mercantile business. In 1852, the partners built the Louisiana House. During the 1870s, Askey lived in San Francisco, where he was appointed wharfinger in 1871 and promoted to assistant chief wharfinger. In 1871, he married Mary E. Brown, the daughter of Judge A. C. Brown of Jackson. He returned to Jackson in 1879 and remained one of the proprietors of the National until his death on March 10, 1894. (Courtesy Amador County Archives.)

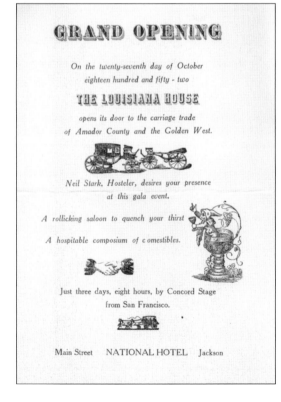

This advertisement, produced well after the beginnings of Jackson, declares that the Louisiana House opened for business on October 27, 1852. How is it known that this was not an ad original to the first opening? There are three clues: the business is advertised as the National Hotel, Amador County was not formed until 1854, and Neil Stark did not purchase the hotel until 1963. (Courtesy Amador County Archives.)

Ellis Evans, a native of Louisiana, arrived in Jackson in March 1850 from the Cosumnes River area with a load of beef to sell. He soon sold out, left, and returned with another load. The meat business proved to be profitable, and he soon opened at store east of Jackson, one at Secreta, another at Butte City, and a fourth larger store at Jackson. He then went into business with D. C. White, also a native of Louisiana, and two years later partnered with his cousin, Armstrong Askey, at the Louisiana House. Evans also served on the county's board of supervisors in 1854 and as county treasurer in 1856 and 1857. (Courtesy Amador County Archives.)

Mary Meek Evans, wife of Ellis, was the daughter of Maj. Hiram C. Meek, who settled near Jackson in 1854. Their homestead covered most of what is today south Jackson. Meek and son-in-law Ellis also opened up and worked the Meek's quartz mine on the property. (Courtesy Amador County Archives.)

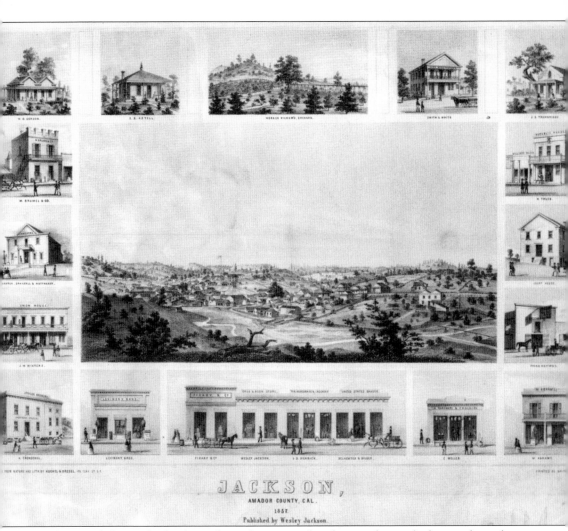

This 1857 lithograph of Jackson shows the extent of settlement that took place in the early years. The buildings seen around the vista represent some of the prominent businesses and homes of the community. (Courtesy Amador County Archives.)

The Union Livery Stable was one of the first businesses established in Jackson. It was associated with the Union House. To the right is an advertisement from an 1861 newspaper, when Frank Hoffman owned the business. The photograph below was taken after Green and Ratto took over the business. (Courtesy Amador County Archives.)

UNION LIVERY STABLE,

Main street, Jackson.

FRANK HOFFMAN, Proprietor

The subscriber respectfully informs his old customers and the public generally, that he has removed to his new and elegant **BRICK STABLE,** near the Union House where persons can be supplied with Swift, Easy and Safe Saddle Horses for Ladies and Gentlemen. Give them a trial, and you will not wish to look further. Also, Horses and Buggies that will not suffer in comparison with the best.

Horses and Mules *Boarded and Groomed* by the Day, Week or Month, on the most reasonable terms. Animals entrusted to his care will be faithfully attended to. A share of public patronage is solicited.

aug 25 45-tf

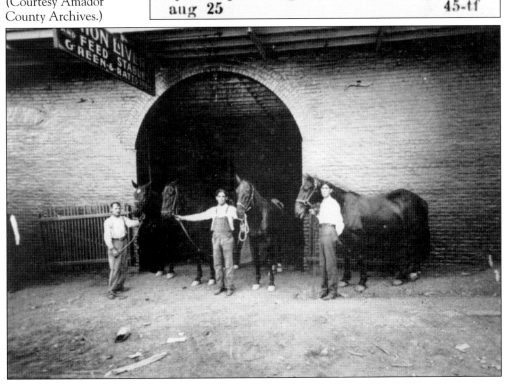

17

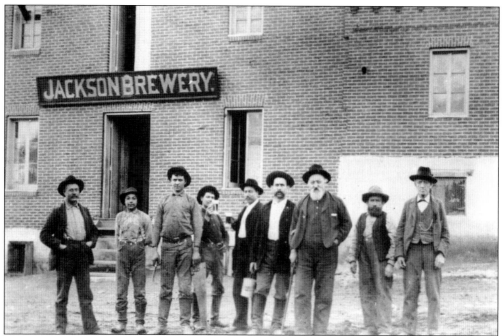

The Jackson Brewery was constructed around 1856 and was operated in the early years by August Trenchel. It was subsequently owned by John Fullen, James Meehan, Benedetto Sanguinetti, Frank Hoffman, and John Holtz. This photograph was taken sometime after 1878, when John Strom owned it. Strom turned the business into a creamery when Prohibition was enacted. (Courtesy Amador County Archives.)

Pictured here is the Tallon blacksmith shop. Henry S. Tallon, far left, went into the blacksmith business in Jackson after working the mines in such places as Virginia City and Bodie. The shop operated for only a short time, after which Tallon returned to his native Canada. In the late 1800s, he returned to Jackson, and on April 13, 1916, he became the Jackson city clerk., a position in which he served until his death in June 1930. (Courtesy Amador County Archives.)

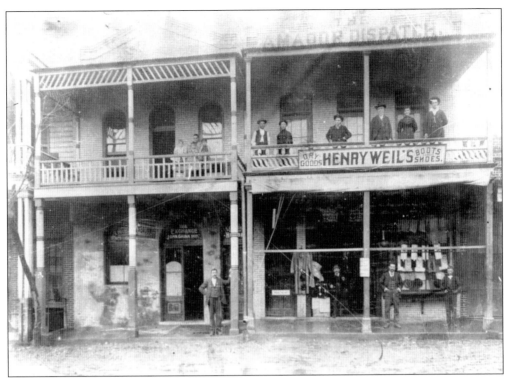

The downtown business district on Main Street in Jackson offered all manner of goods and services. The two buildings pictured here were home to the offices of the *Amador Dispatch* newspaper (top right), Henry Weil's shoe store (bottom right), and the Exchange rooming house, saloon, and theatre (on left). This was John Chinn's theater, and apparently it was a popular place. A 1903 entertainer at the establishment wrote a letter wherein he described an incident in which a banjo player was pummeled with vegetables after performing to a full house. He went on to state that he had never laughed so hard in his life. Chinn operated the Exchange until his death in 1918. (Courtesy Amador County Archives.)

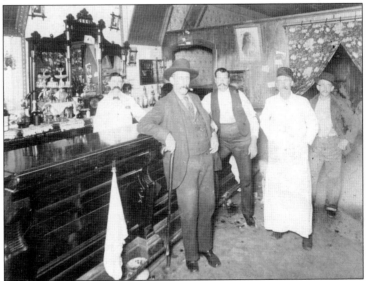

This is an interior view of the Exchange Saloon, operated by John Chinn. Standing from left to right are bartender Charlie Reynolds, unidentified, proprietor John Chinn, and two visiting Cornishmen. (Courtesy Amador County Archives.)

19

William L. McKim, a Kentucky native and surveyor by trade, came to California in 1849. By 1850, he was in partnership with others as co-owner of the Astor House and subsequently served as deputy county surveyor of Calaveras County, was elected to the California legislature, and in 1854 became one of the commissioners to organize Amador County. Additionally, he served as Amador County treasurer and deputy U.S. surveyor. McKim was married to Olive Mann, the widow of Henry Mann, atop Butte Mountain by the Reverend Fish. (Courtesy Amador County Archives.)

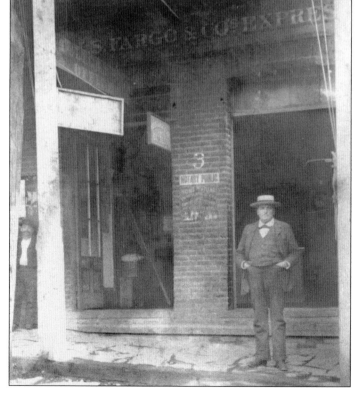

In this *c.* 1875 photograph, Benjamin Richtmyer poses in front of the Wells Fargo Express office that was located at No. 3 Main Street in Jackson. In addition to serving as agent to Wells Fargo, he was for a time the Amador County Clerk, an agent for Western Union, and the proprietor and manager of the Jackson waterworks. (Courtesy Amador County Archives.)

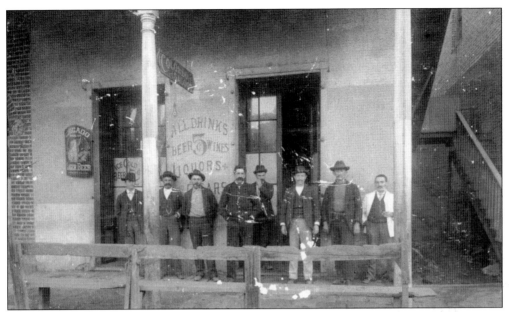

Ever ready to pose for a photograph, these early Jacksonians stand in front of the Colombo Saloon. All men posing for the photograph are unidentified with the exception of John Davitto, who stands at center without a hat. Note the bargain price of only 5¢ for a glass of beer or wine. (Courtesy Amador County Archives.)

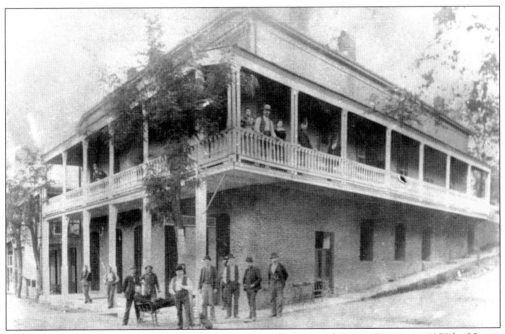

The Globe Hotel was built at the northeast corner of Main and Court Streets in 1858 by Henry Trueb and is the two-story structure pictured here. The building was gutted during the great fire of 1868 but rebuilt soon thereafter. It yet stands in Jackson with a third story, which was added in 1896. (Courtesy Amador County Archives.)

In the old days, there was more than one way to put out a fire—visiting Mitchell's saloon, which occupied the first floor in the building on the left, or ringing the bell at the Jackson firehouse, shown on the right, were the options. The saloon was later the home to the Amador County Chamber of Commerce and various retail establishments. It still stands today as does the remodeled Jackson firehouse. (Courtesy Amador County Archives.)

This group of Amador pioneers poses for a photograph at Stockton, California, in 1909 at a celebration marking California's 60th anniversary of statehood. Seated from left to right are unidentified, John Myers, Charles Peters, and Jim Hayden. Those standing are unidentified, but the gentleman on the right may be Paul Reichling. (Courtesy Amador County Archives.)

Two

TO SERVE THE PEOPLE
STEADFAST INSTITUTIONS

Jackson has been the seat of county government since 1854, when Amador was formed from portions of El Dorado and Calaveras Counties. For a short time prior to the birth of the county, Jackson housed the county records for Calaveras after they were removed from Double Springs, albeit in a not-so-formal manner. In fact, it created such an affray that, after the records were stolen and an election held at Jackson, the presiding Judge Smith murdered the defeated county clerk, Colonel Collyer. Although he was never tried, the judge quickly retired because of pressure from the public. Despite these shaky beginnings, the public institutions of the county have since endured and expanded to serve the citizens of Amador County in a most prestigious manner.

In this chapter, the reader will discover the genesis of the government and meet some of its more prominent individuals. Likewise, non-government institutions, such as Jackson's churches, were important in strengthening the fabric of the community. The first Eastern Orthodox Serbian Church built in the United States is located here. St. Patrick's Catholic Church and the Methodist church have also been steadfast institutions in the town since the gold rush.

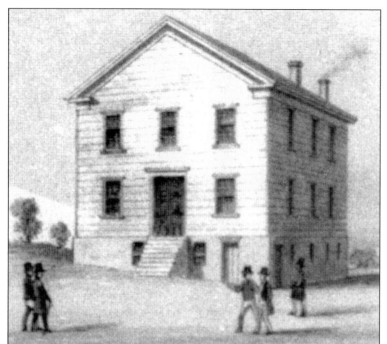

This drawing depicts the first courthouse built in Jackson. The structure also housed the county jail. It was destroyed in a fire that swept through Jackson in August 1862. (Courtesy Amador County Archives.)

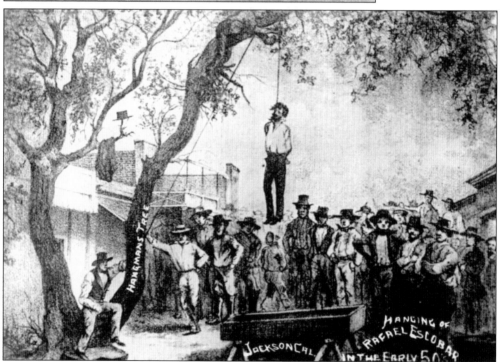

This early sketch depicts the demise of Raphael Escobar beneath the branches of Jackson's famous "hanging tree," which stood on the east side of Main Street near Louis Tellier's saloon. A total of 10 men were hanged from the tree between 1851 and 1855. The great oak was damaged in the 1862 fire and subsequently was cut down. A likeness of the tree was engraved on the first seal of Amador County. (Courtesy Amador County Archives.)

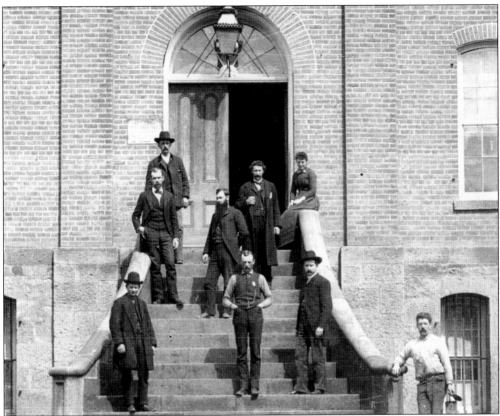

A group of county officials pose on the steps of the courthouse around 1890. (Courtesy Amador County Archives.)

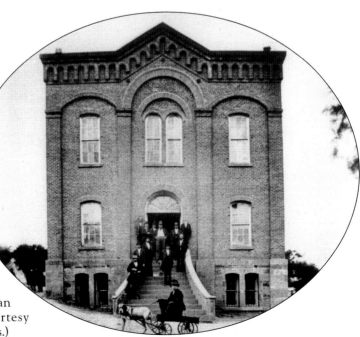

After the first wooden courthouse was destroyed in the 1862 fire, this two-story brick structure, designed by S. D. Mandell and constructed by J. W. Epley, Hatt Canavan, and William Maloney, was built to replace it. It still stands on the hill overlooking Main Street, although it now is covered with an art-deco façade. (Courtesy Amador County Archives.)

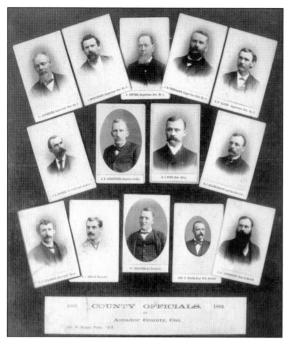

Seen here are the Amador County officials that served from 1891 to 1893. Pictured from left to right are the following: (first row) deputy county clerk S. G. Spagnoli, county recorder A. L. Beale, county treasurer W. Jennings, superintendent of public schools George F. Mack, deputy sheriff J. A. Laughton; (second row) county clerk and auditor G. R. Breese, superior court judge C. R. Armstrong, district attorney R. C. Rust, sheriff and tax collector R. J. Adams; (third row) supervisors Louis Ludekins, John Marchant, P. Dwyer, J. R. Tregloan, R. F. Allen. (Courtesy Amador County Archives.)

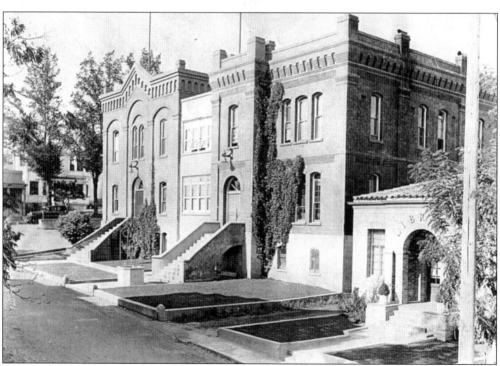

In 1892, the Amador County Board of Supervisors ordered the construction of a new hall of records to be built adjacent to the courthouse. T. J. Welch of San Francisco completed plans for the building to contractor D. J. Brennan. The hall was completed in 1893. Most of the bricks were made on the nearby Muldoon Ranch by Frank Massoni. The open area between the buildings was enclosed around 1920 to provide additional office space. (Courtesy Amador County Archives.)

This flag-draped well once stood at the entrance to the old county hall of records and served as a war memorial to the Amador soldiers who died in World War I. The well was first dug in 1855 as part of a courthouse-improvement program. The memorial plaque, obscured in this image by the flag, was placed here by the Amador post of the American Legion shortly after they were organized in 1919. In 1940, the well was sealed, and the plaque, embedded in concrete, was placed over it. (Courtesy Amador County Archives.)

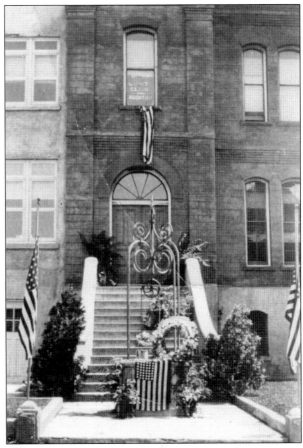

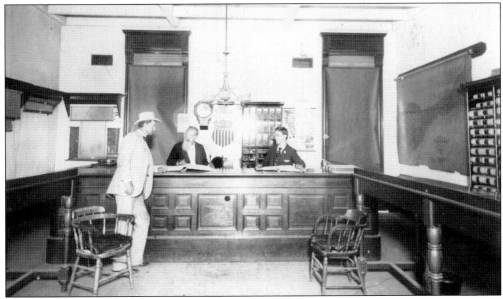

This is a view of the Amador County Recorder's Office, taken in August 1898. Pictured from left to right are George Brown, R. I. Kerr, and D. A. Patterson. (Courtesy Amador County Archives.)

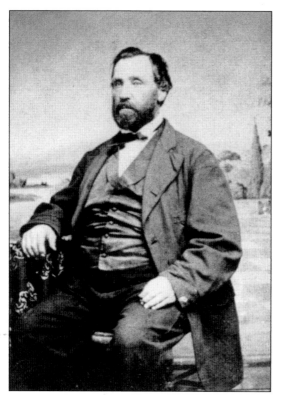

Jesse Foote Turner spent much of his time in Amador County serving the public as he had prior to his arrival in the early 1850s. In New Albany, Michigan, he was well-known as a businessman, and he partnered with his brother to build the town's first hotel around 1838. Ten years later, he was presiding as a county judge there. After his arrival in Jackson, he served as a school trustee and then as a district attorney. In 1863, he became a county judge in Amador and worked in that capacity until 1871, when he became a superior-court judge. Turner remained in that position until his death a short time later in August 1871. (Courtesy Amador County Archives.)

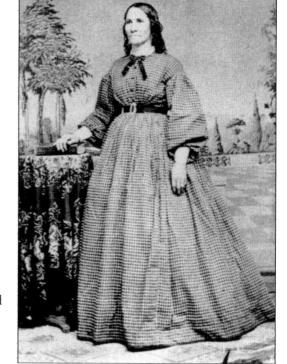

Ellen DeGarmo Turner was born in New York in 1813. At the age of 25, she married Jesse Foote Turner in Cleveland, Ohio, and together they raised a large family. Ellen died in 1903 in Berkeley, California. (Courtesy Amador County Archives.)

It seems that posing on the steps of the hall of records became a tradition for Amador County officials. Pictured here from left to right are the following: (first row) Sheriff T. K. Norman, possibly Loretta Meehan, Judge R. C. Rust; (second row) Judge C. P. Vicini, Leotta Huberty, county treasurer George Gritton; (third row) Anthony Caminetti, Sr., Ed Kay, George Gordon, ? Fisher. (Courtesy Amador County Archives.)

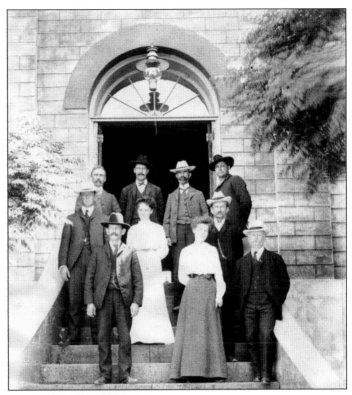

A smiling Judge Fred V. Wood poses for this picture, taken inside the courtroom for the superior court in the 1920s. The diligent worker in the foreground is J. R. Huberty, a longtime Amador County clerk. (Courtesy Amador County Archives.)

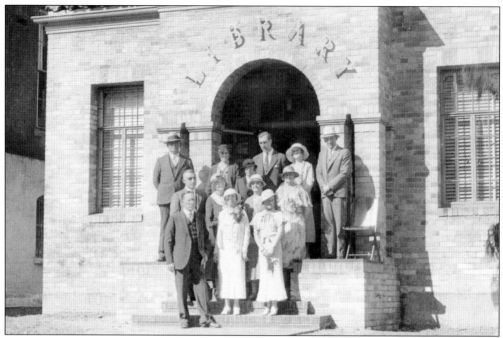

A group poses on the steps of Jackson's first official library building, constructed in the early 1930s. The county library system was established in 1920 with the assistance of Amador County women's clubs. The structure is currently used as a courtroom and until two years ago housed the Amador County archives in the basement rooms. (Courtesy Amador County Archives.)

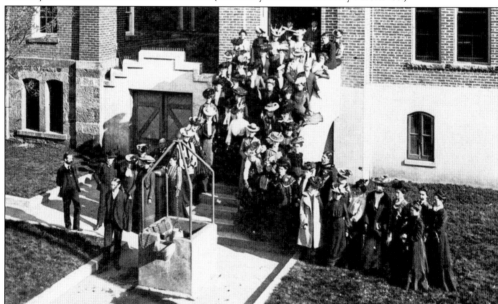

In the early 1850s, when Jackson was being settled, no formal training or certification requirements existed for the teaching profession. From 1859 to 1863, laws were passed to remedy this. In response to state requirements, teacher's institutes were held annually in the local jurisdictions. Here the teacher's institute in Amador County poses for a group shot on the steps of the hall of records in Jackson. (Courtesy Amador County Archives.)

Some things never change, including jump rope and other games played on a school playground. The children of Jackson first attended school in the Methodist Episcopal Church, and then a two-story brick school was constructed near the church in 1858. In 1888, that school building was replaced with the one pictured here. Another was constructed next to it in 1897. Both buildings were razed in the 1940s and replaced with a modern school that is still in use today. (Courtesy Amador County Archives.)

Prior to 1913, students wanting to attend the upper grades had to travel to Ione, which held the only high school in the county. In 1911, the board of supervisors, at the urging of the Woman's Club of Jackson and concerned citizens, held two special elections to vote for a school and issue bonds to pay for it. Although the measures passed, it was two years before the school was completed. During that time, high school education was administered in vacant rooms at the Jackson Grade School. Classes began at the Jackson High School in August 1913. (Courtesy Amador County Archives.)

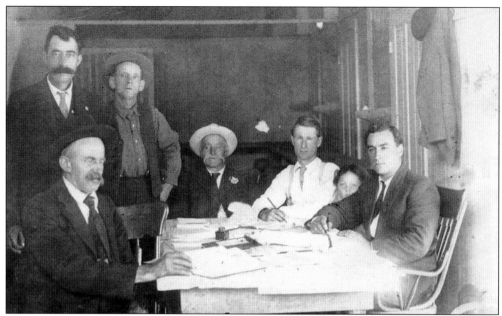

Elections officials in Amador County have always been based in Jackson, it being the county seat. Controversy over election results is nothing new to the voter. When Jackson first became the county seat for Calaveras County, albeit for a short time, a disagreement over the counting of votes prompted a fatal gunfight at the corner of Main and Court Streets. Colonel Collyer, a defeated candidate, was shot dead by Judge Smith, who counted the votes against Collyer. In this image, the election board convenes in the Jackson firehouse. (Courtesy Amador County Archives.)

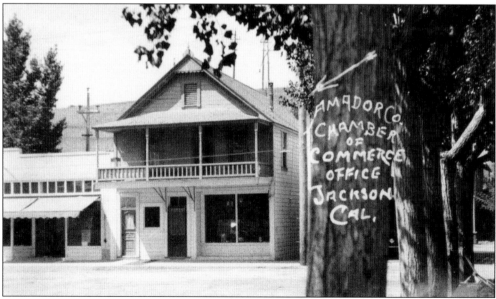

The Amador County Chamber of Commerce, organized on October 29, 1921, was first housed at this location on Main Street. Several ambitious projects were immediately initiated by the organization, one of which was to improve the roadways in the county. This led to the formation of the Mother Lode Highway Association and the Alpine State Highway Club, both of which were instrumental in promoting early tourism in Amador County. (Courtesy Amador County Archives.)

By 1854, when Jackson became the county seat for the newly established Amador County, the town had an organized fire department. This list of members enrolled in the Jackson Hook and Ladder Company was recorded in the town minutes. It was an impressive enrollment considering it was an all-volunteer department as it is today. (Courtesy Amador County Archives.)

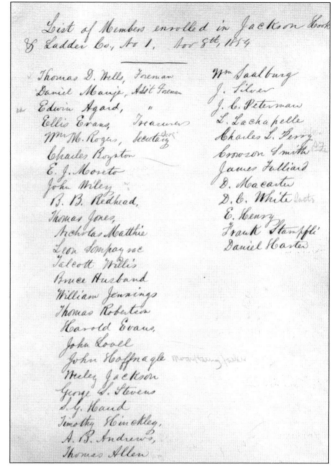

This view of Main Street in Jackson shows the early firehouse on the right. It was built in 1862 by the Jackson Hook and Ladder Company. Note the tower atop the structure that held the warning bell to call the fireman forth in the event of a fire. (Courtesy Amador County Archives.)

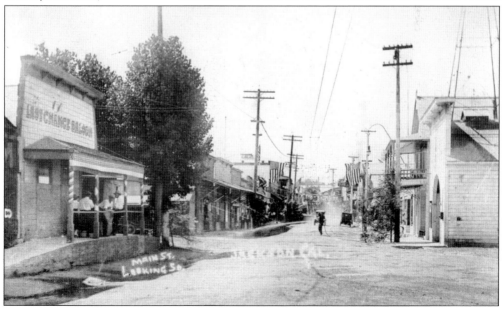

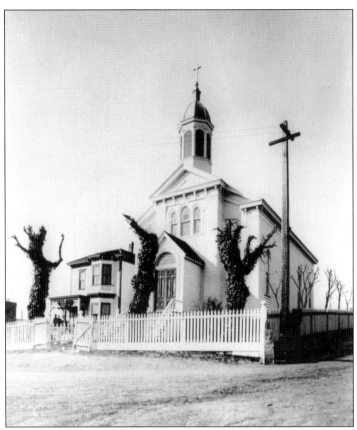

Catholic services were first held in Jackson in a church on Main Street that burned in the 1862 fire. For the next two years, the congregation met in the courthouse. In 1866, a lot was purchased across from the courthouse and this church was built. It was dedicated on May 18, 1868. Ten years later, the belfry tower and cross were blown off in a storm and were replaced by the cupola and cross seen in this photograph taken in the early 20th century. (Courtesy Amador County Archives.)

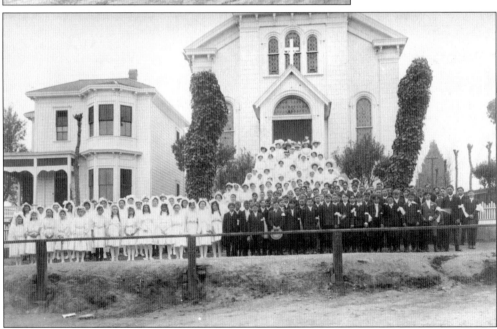

Children pose in front of St. Patrick's on their confirmation day. (Courtesy Amador County Archives.)

The Reverend Issac B. Fish was the first minister of the Jackson Methodist Church. He preached his first sermon in Jackson in the barroom of the Astor House on December 1, 1851. In 1853, he claimed a lot of ground and built his church on the hill overlooking Main Street, near St. Patrick's Catholic Church. (Courtesy Amador County Archives.)

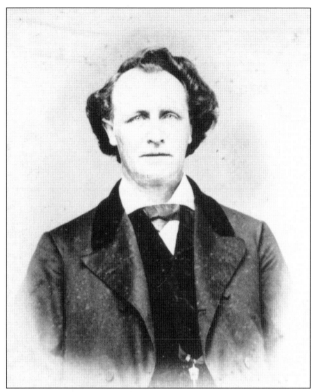

The Methodist Episcopal Church of Jackson has worshiped at this site since 1853. This structure, built in 1868, replaced the original church. It has been remodeled and renovated several times over the past 140 years. (Courtesy Amador County Archives.)

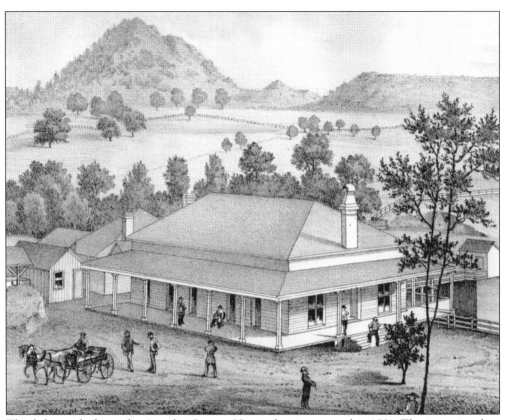

This lithograph shows the Amador County Hospital as it appeared in 1881. The image is taken from Thompson and West's *History of Amador County*. (Courtesy author.)

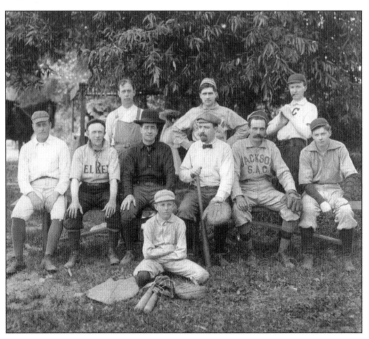

The doctors of Jackson not only cared for the health of the community, they also entertained them. They are seen here as members of the Jackson baseball team. They are, from left to right, as follows: (first row) C. P. Vicini, Dr. Em, Dr. Wilson, Dr. Caldwell, Gus Laverone, Dr. Sullivan; (second row) Emil ?, Dr. Schach, Dr. Endicott; (seated on grass) Ernie ?, the bat boy. (Courtesy Amador County Archives.)

The telephone first came to Jackson in 1878, the line being connected to an established office in Sutter Creek. On June 7 of that year, the first conversation took place between the two towns with crowds gathering at either location to have their chance to talk "over the wire." It must have been a difficult prospect to install the overhead lines during those early days, using horses and wagons to carry the needed poles and wires. Pictured below are telephone linemen with their gear near Jackson. At right is Amelia Cademartori Schacht, the first full-time operator employed in Jackson, sitting at the Sunset Telephone Company switchboard. The company had their offices and switchboard in the Cademartori shoe store. Over the years, the shoe store, along with the telephone switchboard, were housed in several different buildings in Jackson. (Courtesy Amador County Archives.)

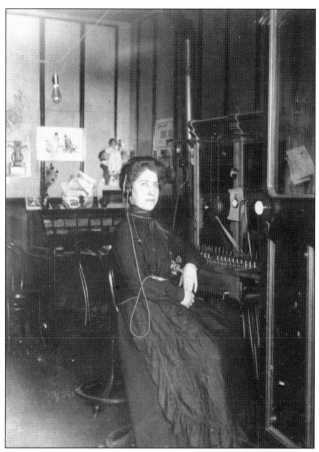

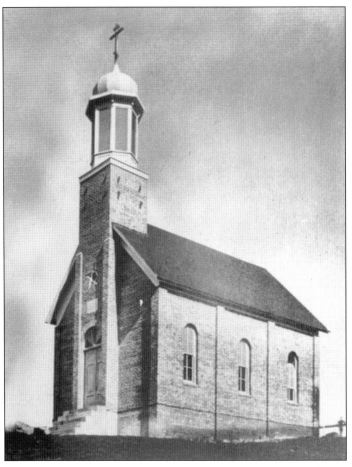

St. Sava Serbian Orthodox Church has been home to the followers of this faith since its dedication on December 16, 1894. It was the first Serbian Orthodox church built in North America, established to serve the numerous Serbian immigrants who made Amador County their home. The adjacent cemetery is the resting place for many of St. Sava's parishioners. The photograph below was taken in 1922 at the burial service for the Serbian miners who perished in the Argonaut Mine disaster. In 1986, St. Sava was added to the National Register of Historic Places. (Courtesy Amador County Archives.)

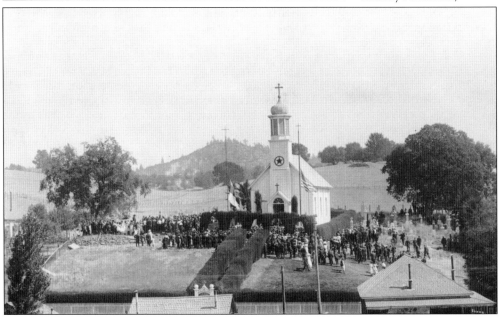

Three

THE SETTLERS
PIONEERS AND
PROMINENT PERSONALITIES

Land has always been the lure of America and its frontiers, but in California the lure was gold. There is something inherently attractive and natural in finding a place that one can belong. For early California immigrants, prompted by untold wealth in the goldfields, the search for that place of belonging ended in Jackson. After the news of John Marshall's gold discovery at Coloma had spread, immigrants flocked to California, swelling the population in the Sierra Nevada foothills.

In 1850, the entire population of California was recorded at 92,597. By 1852, the number of people in the state had grown to 260,949. Living within the boundaries of Calaveras County, which included Jackson and its environs, were 20,192 people. This number accounts for nearly 10 percent of the 1852 population. In 1860, well after Jackson was established, the census counted a total of 2,337 persons living in Township No. 1 of Amador County, which included Jackson and its environs. Although the population of California continued to grow into the 20th century, many of the placer miners left the goldfields to try their luck elsewhere. Those who remained found a place where they felt they could belong.

In this chapter, the reader will be introduced to some of the early settlers and prominent families of Jackson, will see where they lived, and will learn brief snippets of the stories of those who stayed to become merchants and workmen. They operated the hotels, the dry-goods stores, the livery stables, and the saloons. They brewed beer, shoed horses, cut hair, baked bread, and built homes. Their children grew up and became the next generation to keep the town alive. Unfortunately this book is not long enough to tell the stories of all the settlers.

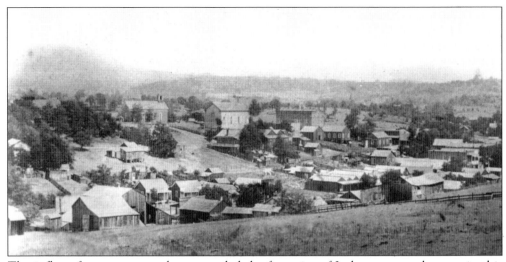

The influx of permanent settlers expanded the footprint of Jackson, as can be seen in this photograph taken around 1887. (Courtesy Amador County Archives.)

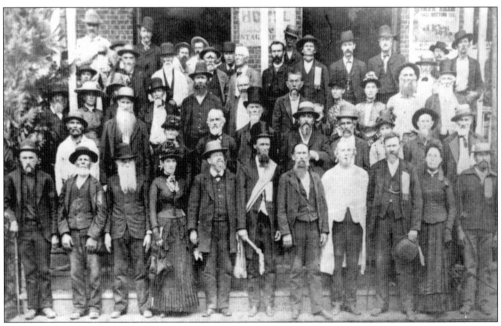

The Amador chapter of the Society of California Pioneers poses for this photograph on the steps of the National Hotel in 1886. Individuals who arrived in California prior to 1850 founded the society. It is kept alive by the direct descendants of the pioneers, who maintain a museum and library in San Francisco where the public can learn about California history. (Courtesy Amador County Archives.)

David Mattley, a native of Switzerland, arrived in Jackson in 1857. Over time, he amassed 2,000 acres, on which he grew hay and raised cattle. Mattley was also a partner in the operation of the Globe Hotel on Main Street for a time. In 1860, he married Mary Yager, and together they raised a family of nine sons. (Courtesy Amador County Archives.)

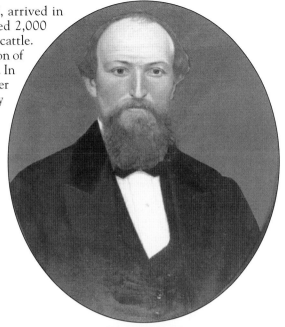

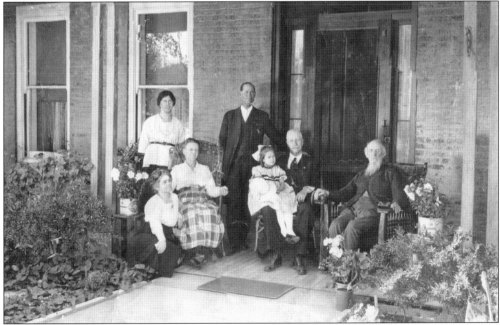

This group of extended family members poses in front of the Armstead C. Brown home. Brown arrived in Jackson in 1850, quickly establishing himself as a businessman and landowner. He served as a town trustee, practiced law, and served as a legislator and county judge. Seated at the center of the photograph is Armstead and Phillipa's son George. The rest of those pictured are, from left to right, Sophie Milovich; Blanche Taylor; George's wife, Mollie Brown; Mollie's cousin Charles Taylor; Helen Taylor (in George's lap); and Mollie's half-brother William Thompson. George and his wife lived in the family home until 1947. Today the house is home to the Amador County Museum. (Courtesy Amador County Archives.)

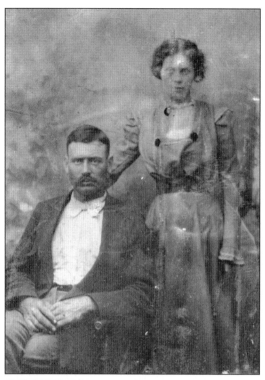

Although Benjamin Ross did not reside in Jackson for any length of time, he is inextricably linked to the early history of the town. Ross arrived in what was to become Amador County in 1852. The hand-drawn 1855 plat map of Jackson that appears in the front of this book (page 8) was drawn by Ross. In 1872, he was appointed U.S. deputy surveyor for mines by surveyor general J. R. Hardenburgh. In 1878, he was elected as a county supervisor, and from 1891–1892 he served as the Amador County surveyor. He is pictured here with his wife. (Courtesy Amador County Archives.)

Pictured below is the home of Anthony Caminetti, one of Jackson's most prominent citizens. Anthony and his wife raised a family of 11 children in this home. Caminetti's contributions to the community and public service are detailed in Chapter Five. (Courtesy Amador County Archives.)

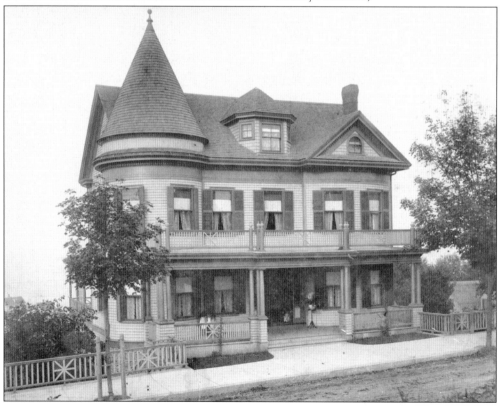

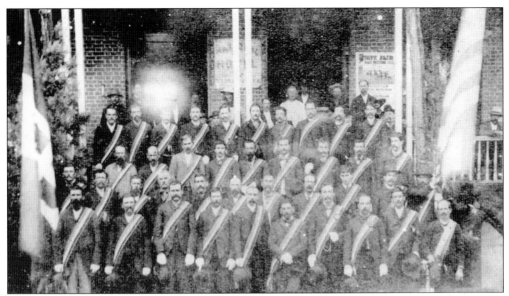

Many early Jackson residents emigrated from Italy. Pictured here in 1884 are members of the Italian Benevolent Society on the steps of the National Hotel. More information on the Italian community in Jackson can be found in Chapter Five. (Courtesy Amador County Archives.)

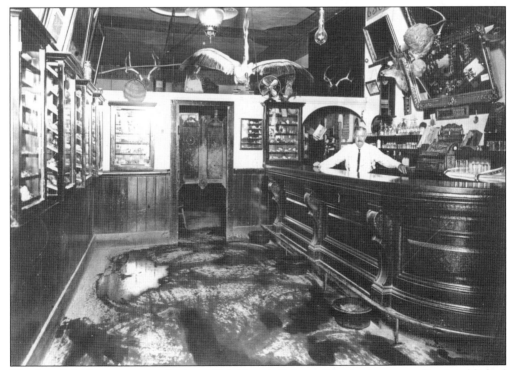

Matthew Muldoon poses at the bar of Muldoon's Saloon. The business was first established and operated by his father Edward Muldoon. A photograph of the Muldoon family can be seen on page 49. (Courtesy Amador County Archives.)

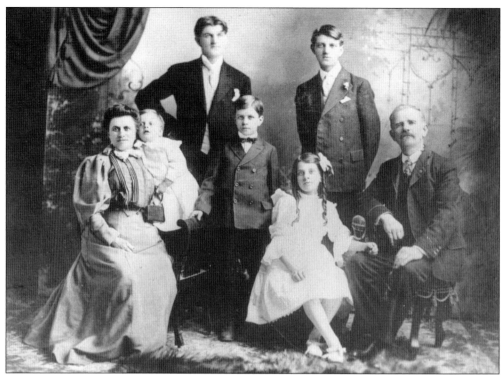

The Tam family name is well-known throughout Amador County. For years, William and his successors operated a store on Main Street. Pictured from left to right are Ameila, baby Renaldo, Charles, Ernest, Inez (seated), William Jr., and William Tam Sr. (Courtesy Amador County Archives.)

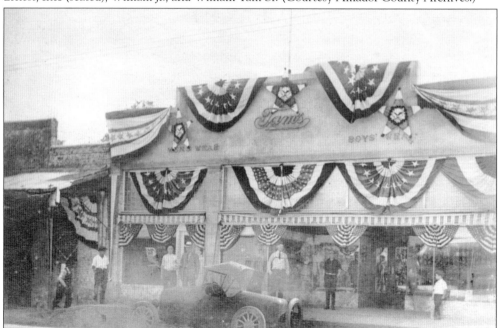

Patriot banners hang over the front of Tam's store on Main Street in this c. 1910 photograph. Note the early automobile in the foreground. (Courtesy Amador County Archives.)

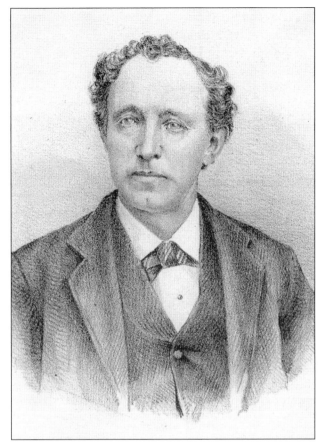

James Meehan came to America from his native Ireland in 1846. Upon his arrival in California in 1850, he struck out for the mines in Tuolumne County and then moved on to Calaveras County, where he worked alongside the famous sheriff Ben Thorne. In 1854, he married Mary Rawles at Volcano. In 1868, James was elected Amador County Treasurer, serving as such for 11 years. He also served for four years as Jackson's postmaster and was president of the Society of California Pioneers for 13 years. James and his wife Mary raised a family of nine children in the home pictured below. (Courtesy Amador County Archives.)

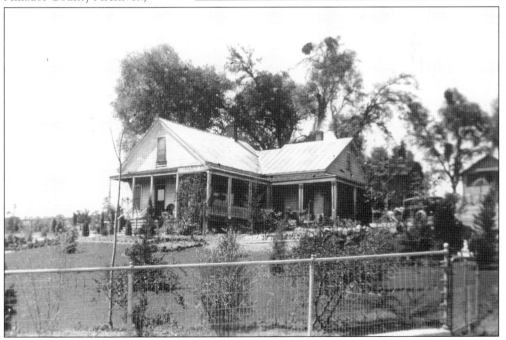

This image of the Parker family and their modest home, situated on the outskirts of the business district, reflects the type of home life that most had at the turn of the 20th century in Jackson. Pictured here, from left to right, are Frederick W. Parker, holding Arthur W. Parker; Charles E. Parker; Ruel Parker; Jack Thomas, a family friend; and Frederick's wife, Sarah M. Parker. Frederick for many years served as the night constable in Jackson. His son Charles worked as the Wells Fargo Express and Western Union Telegraph Agent from 1907 to 1913. (Courtesy Amador County Archives.)

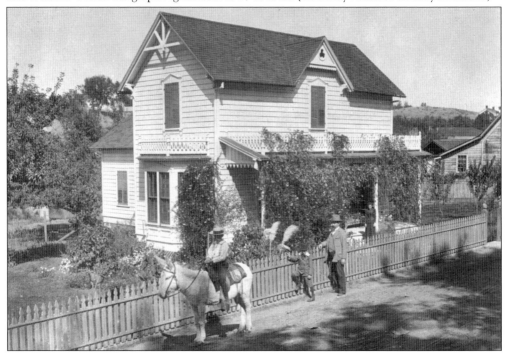

This lovely home was the residence of Louis and Mary Meehan Fontenrose. Louis, who was of Italian descent, immigrated to California in 1857 at the age of seven. In his youth, he assisted his father in the mercantile business and then tried his hand at mining. When his father passed away, he returned to the family store where he worked until he was appointed deputy county clerk in 1879. He served in that capacity through 1880 and from 1884 to 1888. The family members in front of the home are unidentified. (Courtesy Amador County Archives.)

Lily O. Reichling Dyer (left), pictured here with a companion, is known throughout California as the founder of the Native Daughters of the Golden West. Dyer held a meeting on September 11, 1886, in Jackson and invited native-born California women to join. On that day, 13 young women enrolled in the fledgling organization. On September 25, the organization was formalized and given the name Ursula Parlor No. 1. Within one year, 17 parlors had been established throughout the state. Dyer was officially recognized as the mother of the order and accorded lifetime membership. (Courtesy Amador County Archives.)

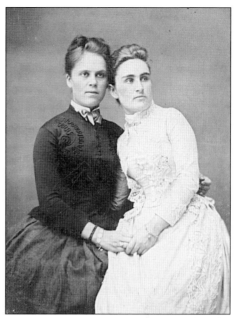

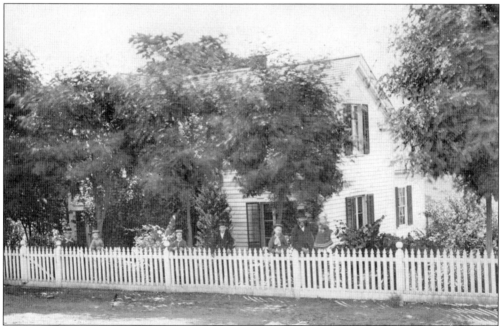

The Reichling family poses outside their home on Broadway in Jackson. Peter Reichling, the family patriarch, immigrated to America from Germany in 1856 and settled at Volcano, where he went into business with his brother buying gold from the miners. In 1858, he came to Jackson and opened a jewelry store. In addition to his retail business, he served as a private banker for the miners, assayed gold, and formed two branch banks at Mokelumne Hill and Lancha Plana. In 1861, he married Antonia Kroll, with whom he raised six children. For a time the family moved to San Francisco and then returned to Jackson, where he operated the Anita Mine for a time. He also became a partner in the Kennedy Mine and was superintendent there for 10 years. (Courtesy Amador County Archives.)

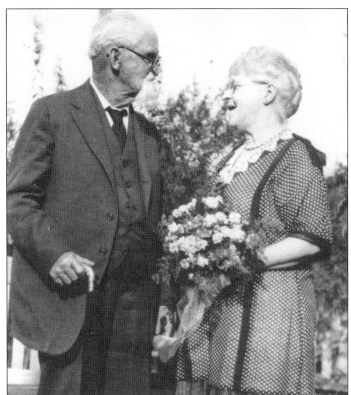

Pictured here on his golden wedding anniversary with his wife, Luella, Sheldon Monroe Streeter was born in Jackson on February 14, 1851. He is credited with being the first white child in the town, and his birthplace is said to have been in a tent where the courthouse now stands. In 1876, he married Luella McMurry, a resident of Ione, and together they raised eight children. Streeter moved from Jackson shortly after his marriage and never returned. He died in Ceres, California, in July 1929, at the age of 79. (Courtesy Amador County Archives.)

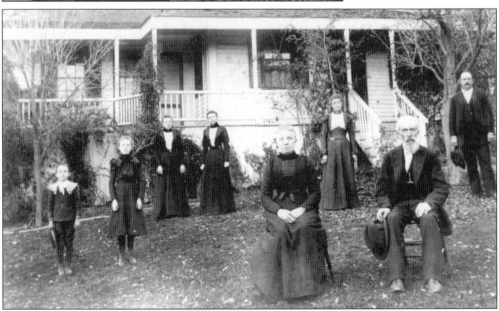

William and Catherine Schroeder emigrated from their home in Holstein, Germany, to California in 1870. After a short stay at the home of a brother, they homesteaded land just outside of Jackson. They are pictured here (sitting) with their family. The members are, standing from left to right, grandson Maney Calvin; granddaughter Meda Calvin; daughters Christina, Minnie, and Carrie Schroeder Calvin; and son-in-law Dick Calvin. (Courtesy Amador County Archives.)

The Muldoon family name is well-known throughout Amador County. Edward, the family patriarch, arrived in the early years of the gold rush and soon established himself as a businessman and rancher. His business interests included the Muldoon Mine, a saloon, a couple of tenements on Main Street, and ranching endeavors. In 1888, when the citizens of Jackson voted to build a new brick schoolhouse, they contracted with Muldoon to provide the bricks, which he fired in a new kiln built at his ranch. Seated are Edward and his wife, Rose Ann McCaffrey Muldoon. Daughters Catherine (left) and Grace (right) are standing next to their parents. Standing behind are their children, from left to right, Rose, John, Matthew, and Belle. (Courtesy Amador County Archives.)

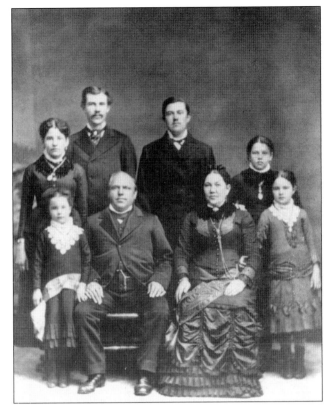

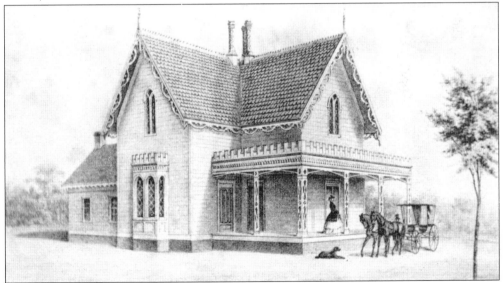

This Carte de Visite is a depiction of what is known as the Voss home. This house created a sensation when it was built in 1860, and lottery tickets were sold for a chance to win it. Charles Parish, builder of the Voss house, was an artist, designer, architect, and carpenter. Over the years, the home has been occupied by various owners and has undergone architectural changes. The present owners, Jerry and Jeanette Chaix, have devoted the past several years to restoring the gothic structure to its original design and furnishing it with period pieces. (Courtesy Amador County Archives.)

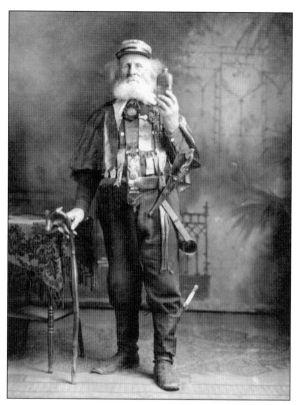

Charles Peters, who was of Portuguese descent, was a 49er to Jackson. Upon his arrival, he took up the trade of selling vegetables from the back of a horse. In 1851, he purchased a canvas house located near the site of the Louisiana House. Thereafter, he took up mining as owner of the South Jackson Mine. Charles lived well into his nineties and was known as a great storyteller. He was a longtime member of the Society of California Pioneers. He is pictured here at 90 years of age. When this photograph was taken, he boasted that he was the owner of Gen. Ulysses S. Grant's uniform, which was worn by Grant when he ran for president of the United States. (Courtesy Amador County Archives.)

Frank Hoffman arrived in Jackson in 1852 and opened a livery stable. A newspaper advertisement for his business can be seen on page 17. Hoffman also farmed a large tract of land west of town and was a member of the Jackson Brass Band. Today, if one travels up Hoffman Street from Highway 49, he or she will pass through a residential area that once was the ranch of Frank Hoffman. (Courtesy Amador County Archives.)

Four

BANKS, BARROOMS, AND BROTHELS
THE BUSINESS DISTRICT

It is said that during the California gold rush, the only people who made fortunes were those who sold supplies to the miners. Many of them arrived with just the shirt on their back in need of everyday necessities, and it was the entrepreneurs who met these needs. Although prices were high, because of the difficulty of delivering goods to the remote towns like Jackson, no one complained. In those early days, gold was being washed from the streams aplenty. As profits grew, so did Jackson as a center of commerce.

In the summer of 1850, there were only seven permanent buildings standing in Jackson's business district. However, by the fall, so many people had arrived that there were nearly 100 houses standing in and around Main Street. By 1854, when Jackson became the seat of the newly formed Amador County, business was thriving, and many new establishments opened up on a permanent basis. The town even boasted a pitch-wood gasworks that supplied the buildings through wooden pipes. As the decade turned into the 1860s, the days of panning gold from the streams had pretty much passed, and a more settled population replaced the transient miners of the early days. Schools were built, banks opened, and the "downtown" of Jackson became a crossroads and merchandising center for the local community as well as for the surrounding area.

The Jackson business district today is much as it was 100 years ago with only cosmetic changes. However, many of the very early buildings that stood were lost in the 1861 flood and the "great fire" of 1862. The latter took down nearly the entire town with the exception of a few brick buildings on Main Street and several houses to the south of town. Because of the number of early buildings that yet stand, Main Street Jackson has been listed on the National Register of Historic Places.

The Parker general store occupied the lower floor of a building that once stood on the southeast corner of Court and Main Streets. It was on this lot, prior to the fire of 1862, that the county clerk's shanty stood. The term "general store" meant just that—all manner of goods were sold, from potatoes to safety fuses, as seen in front of the store, to yardage for dresses and men's accoutrements, which was displayed in the windows. This photograph was taken around 1898. The men standing at the storefront are, from left to right, unidentified, ? Dunning, George Kirkwood, and Ruel Parker. (Courtesy Amador County Archives.)

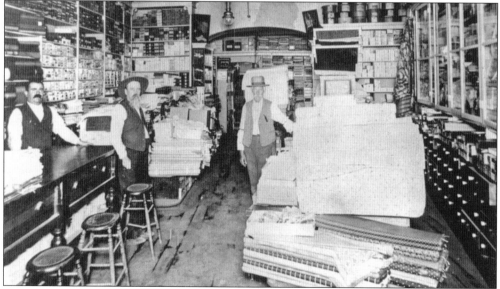

The store of Enrico and Alphonse Ginocchio was described in 1927 as the largest and most well-stocked mercantile business in Amador County. By that time, the Ginocchio family had been in business for nearly 70 years. Their enterprises also included warehouses, a lumberyard, and a fruit drier near the Water Street store. In 1889, the Ginocchio brothers displayed at the California State Fair a sample of dried Zanto currants, which were the first specimens ever exhibited. The family also invested in Amador's mining industry and participated in community organizations. Enrico served as the first secretary to the Societa Italiana Garibaldina, the precursor to the Italian Benevolent Society, when it was formed in 1864. (Courtesy Amador County Archives.)

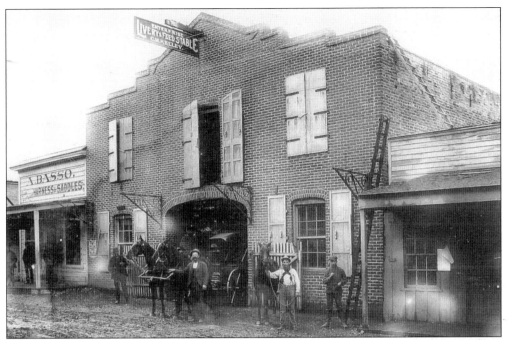

Pictured here is historic Jackson's version of the auto mall. Just like today, everybody in the early days needed transportation and a place to park their vehicles when they came to town. The Enterprise livery stable of C. M. Kelley and the adjacent harness shop of Andrew Basso stood on the west side of Main Street below today's El Dorado Savings Bank. (Courtesy Amador County Archives.)

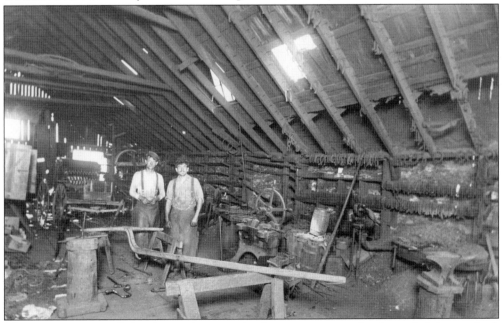

Likewise, citizens needed a place to have repairs done to wagons and to have their horses shod. This interior view of Angelo Piccardo's blacksmith shop shows a wagon tongue up for repair. Note the hand drill on the floor under the tongue and the numerous horse and mule shoes hanging from the rafters and beams. (Courtesy Amador County Archives.)

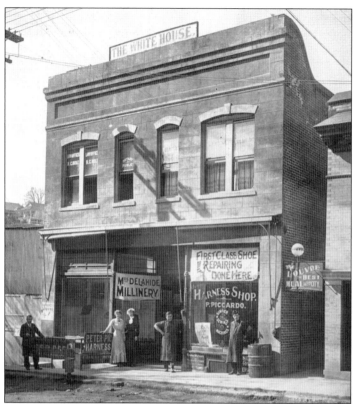

In the 1890s, the businesses that occupied the White House building offered shoppers a variety of goods and services, from harnesses to hats and sewing machines to shoe repair. One could even have legal matters taken care of on the second floor at the notary public or at the law offices of R. C. Boles. (Courtesy Amador County Archives.)

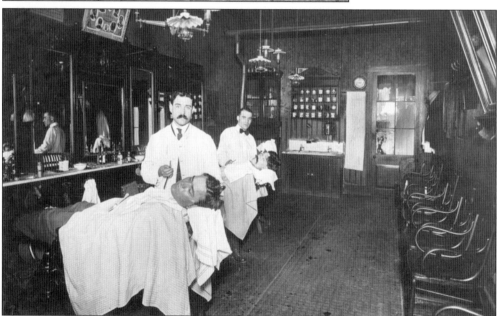

Some things never change, such as a nice shave and haircut in the barber's chair. This photograph of Paul Poggi's shop was taken in the early 20th century. Poggi is the barber standing at the chair in the foreground. The other barber may be Basilio Ricci, who worked for Poggi in 1918. (Courtesy Amador County Archives.)

Henry Weil emigrated from Germany in 1882 and settled at Jackson. He operated a shoe store for a time until moving on to San Francisco. (Courtesy Amador County Archives.)

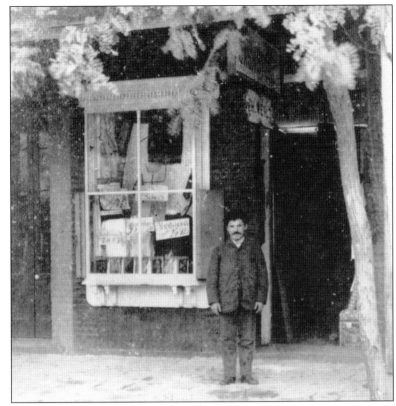

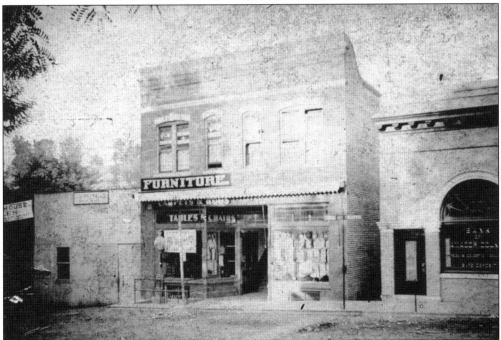

Another view of the White House building shows that it was also home to a furniture store for a time. (Courtesy Amador County Archives.)

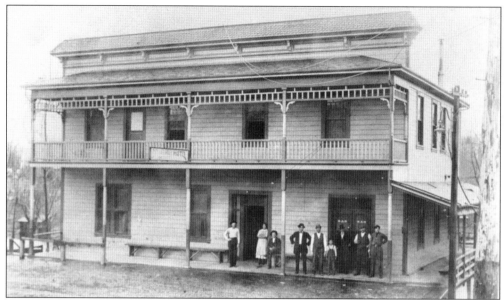

Such was the need for housing for travelers that the business district of Jackson extended well beyond Main Street. The Broadway Hotel is located approximately a quarter-mile north of town in a residential area. This photograph was probably taken shortly after Italian immigrants Pietro Giurlani and Paolo Marcucci constructed it in 1904. Today the building appears much the same as it did in the early days. (Courtesy Amador County Archives.)

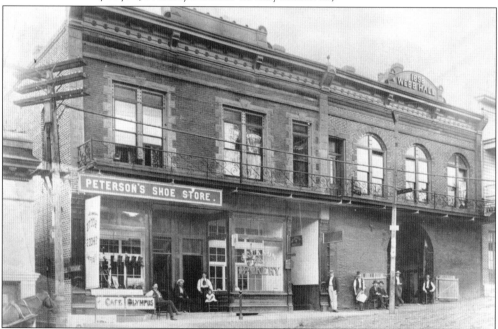

The Webb building has been a landmark on Main Street since its construction in 1898 by *Amador Ledger* owner and editor Richard Webb. The building was actually a large add-on to a smaller structure. The bottom right of the building was originally the livery stable of Frank Hoffman. Webb then added a second story to this and built the two-story section on the left. (Courtesy Amador County Archives.)

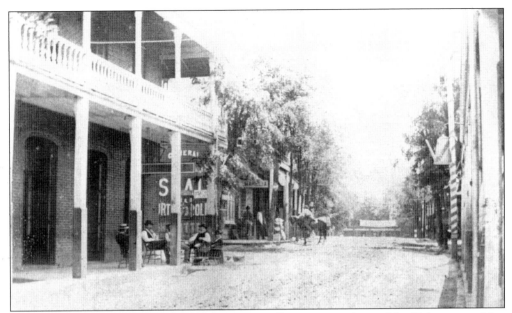

This early view of Main Street depicts the quiet small-town atmosphere of the 19th century. Men relax in front of the Globe Hotel, while others shop at the Marelia and Company store, seen just beyond the hotel. (Courtesy Amador County Archives.)

Wells Fargo and Company established offices throughout the West as towns sprang up. Soon thereafter, the Western Union Telegraph Company established offices as well. Charlie Parker, standing at center of this 1907 photograph, served as the agent to both companies. (Courtesy Amador County Archives.)

"Bread being the staple of life," or so it is said, means that every town needs a bakery. The Jackson Bakery was one of many that served the town over the years. (Courtesy Amador County Archives.)

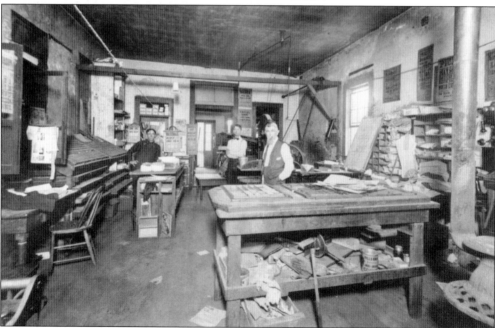

From the time colonial revolutionaries influenced public opinion in young America to seek their political independence from England, the newspaper has been a staple for Americans. Pictured here is the printing office of the *Amador Dispatch*, founded in 1860 by William Penry Sr. It was first printed in Lancha Plana before moving to Jackson. William Penry Jr. succeeded his father, the proprietor and editor. (Courtesy Amador County Archives.)

Enterprise comes in many forms, and for the Marre family it was through various enterprises. When Agnelo Marre, the family patriarch, first arrived in Jackson in 1868, he opened up a boarding house above the Kennedy Mine. After the Zeile Mine opened at the south end of town, he purchased a lot at the corner of Broadway and Bright Avenue and erected the hotel seen below. The family then constructed a two-story building across the street out of which they operated a wholesale liquor and wine business. The hotel is no longer standing, and the building that housed the wholesale business is today a private residence. (Courtesy Amador County Archives.)

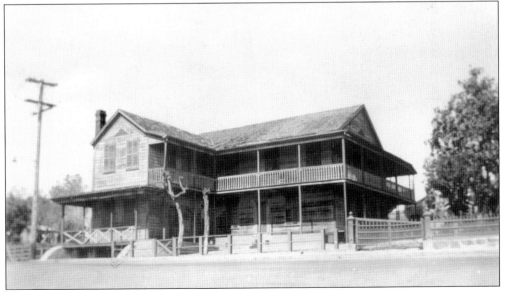

NET CONTENTS 11 FLUID OZ.

Gold Foam

THE HOME INDUSTRY

BEER

BREWED AND BOTTLED BY

JOHN STROHM
JACKSON, CAL.

Pictured here is the no-longer-extant Jackson Creamery and Ice Company Building (below), formerly the Jackson Brewery, and a beer label printed for the establishment (above). German immigrant and brewmaster John Strohm first rented the brewery in 1886 and subsequently purchased it. When Prohibition was passed, he converted the business to a creamery and supplier of ice. The plant produced all manner of dairy products, including ice cream and butter. Strohm received a first prize at the 1920 California State Fair for his Golden Nugget butter. In addition, the factory also bottled soft drinks, including an "artificial champagne cider." The title of this concoction may have been created to appease those who, prior to Prohibition, imbibed in the real stuff. The building was torn down in 1960. (Courtesy Amador County Archives.)

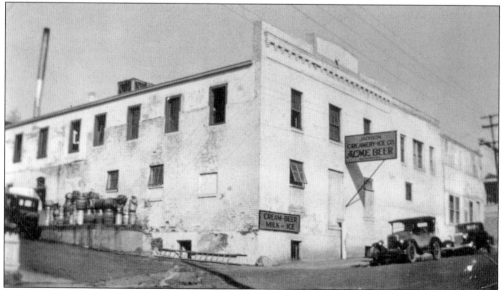

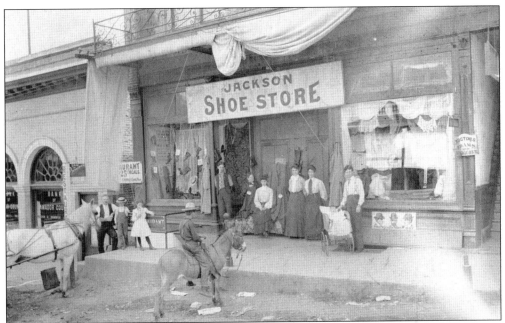

The Jackson shoe store, pictured here, is at the same location as Peterson's shoe store, seen on page 56. Note the difference between the two photographs, and one can see the genesis of a town in a microcosm. This photograph, taken c. 1910, shows more of a family influence, with women and children included in the photograph. (Courtesy Amador County Archives.)

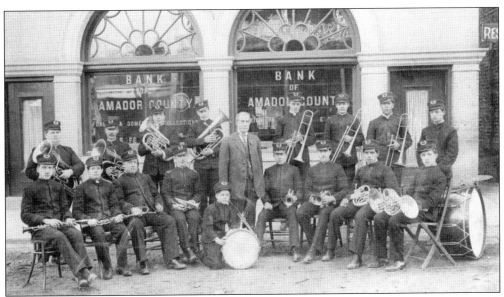

The Bank of Amador, founded in 1897, is the backdrop for this photograph of the Jackson Band. The band members are, from left to right, the following: (seated) George Schacht, John Rule, Frank Sanguinetti, John Cademartori, Robert Kerr, Chub Green, Charles Rugne, Paul Parker; (standing) Julius Piccardo, Ben Gilbert, Jeff Dal Porto, Albert Sutherland, conductor C. L. Davenport, William A. Tam, John Batcheler, Guido Giannini, Frank Cuneo. Ernest Tam, the drummer, kneels in front of the group. (Courtesy Amador County Archives.)

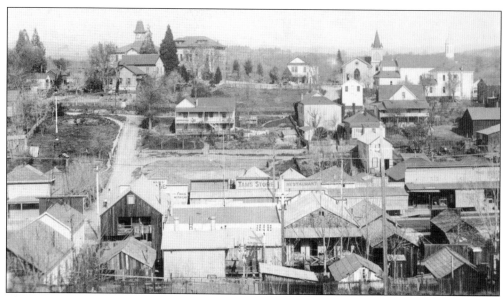

The view of Jackson, taken in the early 20th century, gives a bird's-eye view of the south end of Main Street and the grade school and churches atop the hill overlooking town. (Courtesy Amador County Archives.)

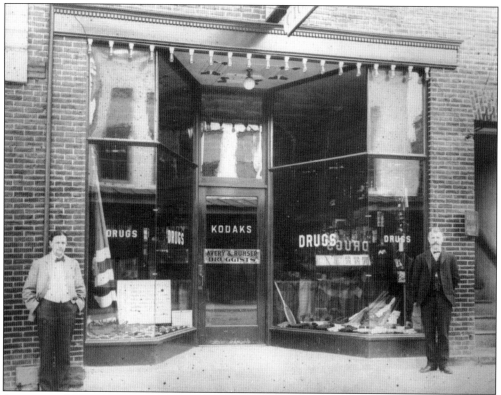

A necessity for any community has been the corner drugstore. Avery and Rusher operated their apothecary on Main Street for a number of years, and then the site became home to the modern-day Rexall Drug store. (Courtesy Amador County Archives.)

This is a view of a fire raging on Laughton Hill, named for James Laughton, who was an early rancher near Jackson. One wonders if the fire department cooled down with a 5¢ Jackson lager after they put out the blaze. (Courtesy Amador County Archives.)

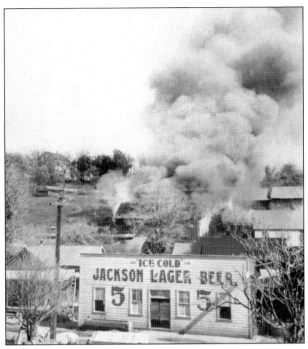

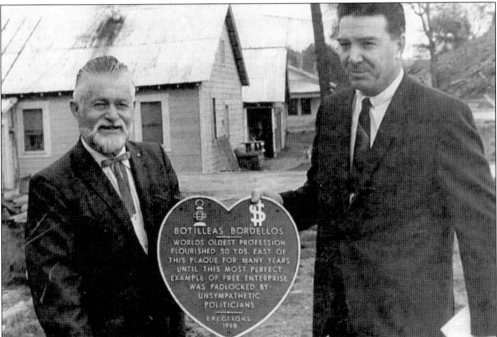

Since the early days, the "oldest profession" of prostitution flourished in Jackson until 1954, when state attorney general Edmund G. Brown spearheaded a campaign to rid California of this form of "entertainment." Sid Smith (left) and author Charles Hillinger are seen holding a plaque that was commissioned by a group of local men to commemorate the historic Bottileas Bordellos. For a time, the plaque was mounted on Main Street, but it was removed amid protests from some local residents. (Courtesy Amador County Archives.)

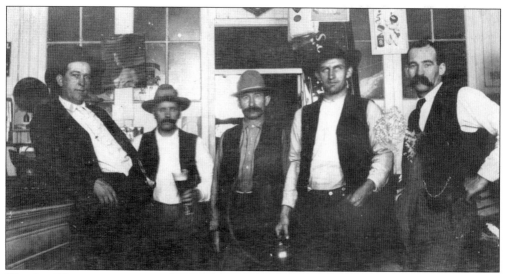

Charles Oliver, proprietor of a grocery store on Main Street, is pictured here (at far right) with a group of patrons enjoying a beverage inside his shop. (Courtesy Amador County Archives.)

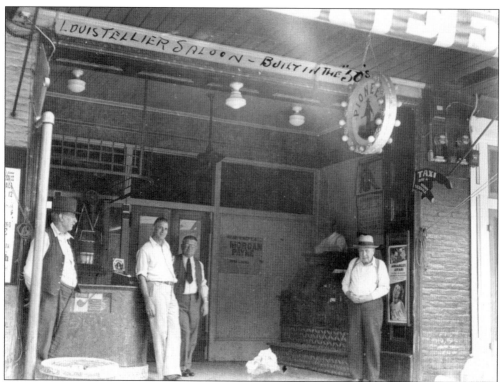

This building was home to a saloon for over 150 years. Louis Tellier, credited with being the first permanent settler in Jackson, opened his establishment for business here in 1850. The name of the saloon is not known, but early visitors refer to a place called the "Frenchman's hut." The establishment operated under various owners until it closed down in 2003. This photograph was taken in 1931. (Courtesy Amador County Archives.)

Five

FROM AROUND THE WORLD
A DIVERSE POPULATION

The gold rush came to California on a swift horse carrying riders from around the world. Jackson, like other early mining camps, drew a variety of ethnic groups. More than 90,000 people made their way to California in the two years following the discovery of gold, and more than 300,000 had arrived by 1854. Jackson's immigrant population included Austrians, Chinese, French, Germans, Irish, Scots, Serbians, Italians, Spanish, Cornish, and many more. The Italians and Serbians formed a substantial portion of the population. The area along Broadway was known as "Little Italy." The Serbians chose Jackson to build their first Serbian Orthodox church in the United States. The French were well-known for their gardens and orchards. Many German immigrants who came to Jackson became prominent businessmen and civic leaders. The Irish, Scots, and Cornish were among those who worked in the mines, which supported the economy of Jackson and surrounding towns. The coming together of these diverse groups has made Jackson what it is today. Many descendents of these people still live in the community and celebrate their heritage at annual celebrations. The Italian community hosts the Italian Picnic and Parade the first weekend in June each year. Every December, the Mother Lode Scots host a Christmas walk in Volcano and invite the community to join them in celebrating their Celtic heritage. The Serbians also hold an annual open house event at St. Sava's Church in Jackson.

Prior to the arrival of immigrants into the Jackson area, the Mi-wuk native peoples occupied the land for thousands of years. According to two Native American women, Mary and Sally, who were interviewed some time around 1900 by anthropologist Samuel Barrett, the village where they were born was located just east of Jackson and was called Hayagetci. Barrett was also told of Yuluni, another village site approximately two miles from Jackson. In 1898, reservation land known as the Rancheria was set aside for the Jackson Bank of Mi-wuk. The Rancheria is now home to a large casino and entertainment center. The Jackson band of Mi-wuk Indians contribute to many community charities and events, provide needed programs for their people, and carry on their heritage through various events throughout the year. Because they were the first people here, the story told in this chapter begins with them.

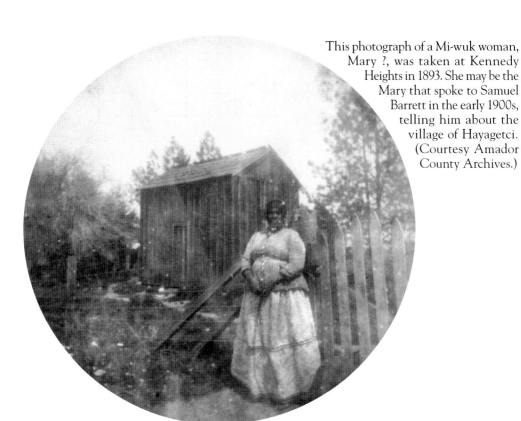

This photograph of a Mi-wuk woman, Mary ?, was taken at Kennedy Heights in 1893. She may be the Mary that spoke to Samuel Barrett in the early 1900s, telling him about the village of Hayagetci. (Courtesy Amador County Archives.)

This photograph, taken in the early 1900s, is labeled "the Indian village at Jackson." It is not known where it was taken but may be an early view of the Rancheria. (Courtesy Amador County Archives.)

Although the Mi-wuk people utilized a number of plants and seeds, their staple plant food was the acorn. They were ground into meal by the use of a hand-held stone pestle and pressed into a stone cup, or mortar. The bedrock mortar pictured at right is known as Chaw'se, the Mi-wuk word for grinding rock. It is located near Volcano at Indian Grinding Rock State Historic Park. A unique feature of Chaw'se is a number of carvings in the surface of the rock that include animal and human tracks, wheels, animal figures, and wavy lines. Several times a year, ceremonies are held in the *hun'ge* (the Mi-wuk word for roundhouse) by local Native Americans. Dancers in native costumes walk past the *hun'ge* in the image below. (Courtesy Amador County Archives.)

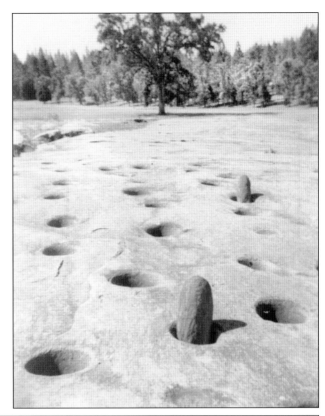

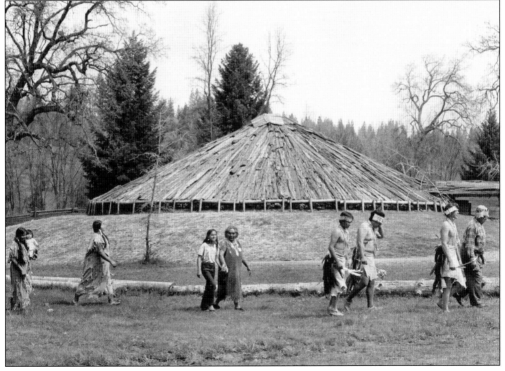

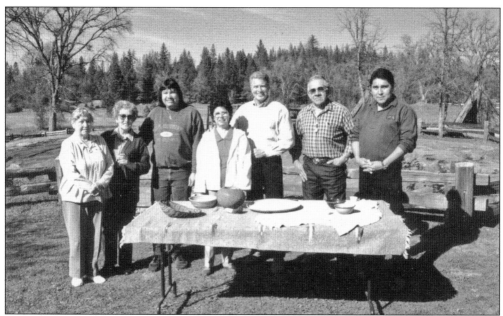

Local Native Americans gather for a special event at Chaw'se with television personality Huell Howser. Pictured are, from left to right, Sarah Coran, Rita Nunes, Marcus Peters, Jen Denton, Huell Howser, Alvin Walloupe, and David Snooks. (Courtesy Amador County Archives.)

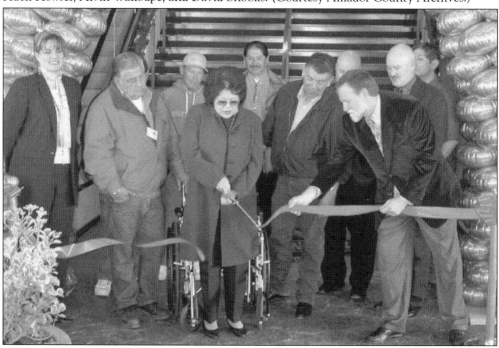

In 1979, the Jackson band of Mi-wuk Indians established their own tribal government. In 1985, the tribe opened a bingo hall on the Rancheria property and, in 1991, expanded it into a gaming facility. In 2005, another expansion project at the casino was completed, adding a new hotel and conference center. In February 2005, Margaret Dalton cut the ribbon at the grand-opening ceremonies for the new facility. (Courtesy Amador County Archives.)

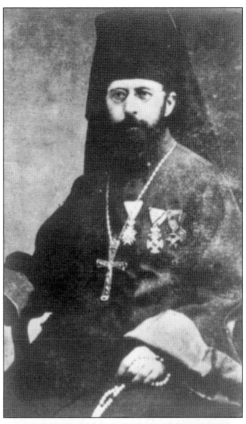

Serbians have been prominent in Jackson since the early 1850s. Pictured at right is Fr. Sebastian Dabovich, the founder of St. Sava church in Jackson and the first Serbian Orthodox priest in America. In 1886, the St. Sava Benevolent Society purchased a parcel on which a cemetery was established. Then, in 1894, Father Dabovich urged the Serbians to build a church. After collecting funds from various sources, the church was built on the hill at the center of the cemetery. The church bell that was cast in Jackson still hangs in the belfry today. In addition to providing a place of worship for the Serbian community, St. Sava's established a children's camp in 1961. Pictured below is the Serbian Gymnastics Team, the Amador County Sokols, who performed at the 1939 World's Fair Exposition in San Francisco. (Courtesy Amador County Archives.)

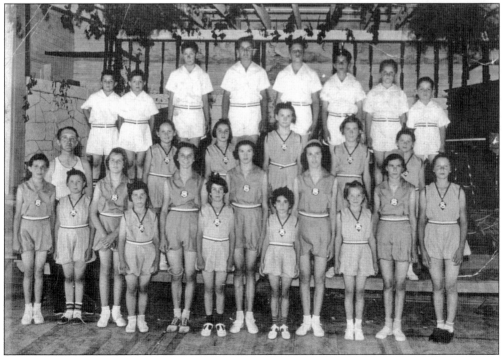

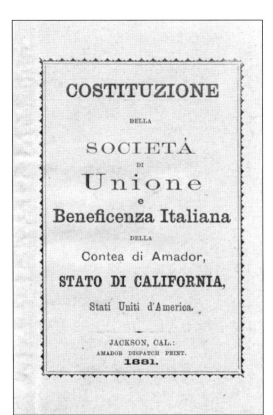

The comfort of close association with others who share a common heritage has been something immigrants have sought out since America's colonial times. Such was the case in 1881, when members of the Italian community in Jackson formed the Societa di Unione Beneficenza Italiana, which translates in English to the Italian Benevolent Society. (Courtesy Amador County Archives.)

Dignitaries of the Italian Benevolent Society take to the stage for speeches and recognition during an Italian picnic celebration in the 1890s. Every year, since its founding, the society has held an annual picnic and parade the first weekend in June to celebrate its members' heritage. (Courtesy Amador County Archives.)

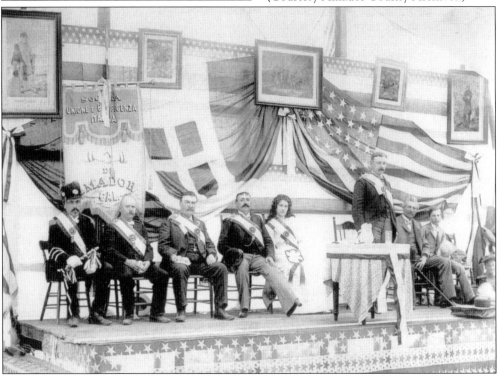

Anthony Caminetti is probably the most well-known of Jackson's Italian sons. He was born just north of Jackson, at Jackson Gate, on July 30, 1854. As a young man, Anthony attended law school and set up practice in Jackson with Senator Farley. In 1879, he took the office of district attorney, followed by service in the state assembly in 1883 for several non-consecutive terms. In 1886, he was elected to the state senate. While in office, among his many achievements, he wrote the bill to erect a statue commemorating James Marshall's discovery of gold at Coloma, introduced the bill establishing California's Admission Day, and was instrumental in the formation of the Preston School of Industry at Ione. (Courtesy Amador County Archives.)

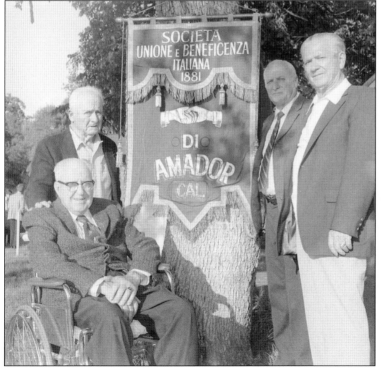

Pictured here are 50-year members of the Italian Benevolent Society. They are, from left to right, Joe Cuneo, John Lagomarsino (sitting), John Ferreccio, and Severino Bellotti. The photograph was taken in 1981. (Courtesy Amador County Archives.)

Jackson's Chinatown once stood near the north end of Main Street. In 1878, a heavy rainstorm washed away most of Chinatown. They rebuilt it, and as late as 1898, an insurance map of Jackson shows the presence of a Joss house at this location. The man pictured here, whose name is not known, was thought to be a resident of Jackson for over 60 years. (Courtesy Amador County Archives.)

When news of the gold rush reached Canton in 1848, thousands of Chinese left their homeland and sailed to California, or Gum Shan, which translates in Chinese to "gold mountain." From the time they arrived, they worked long hours for low pay and were resented by whites. This steel engraving from 1873 shows Chinese miners hard at work prospecting for gold. (Courtesy author.)

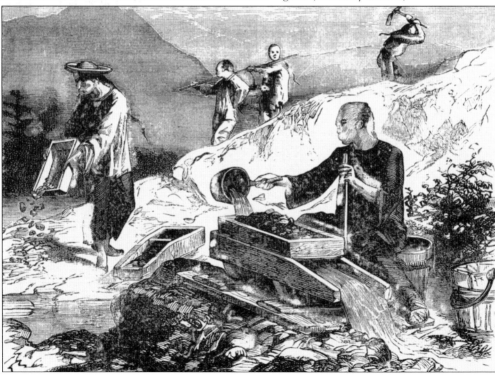

The Chinese, like other ethnic groups, held fast to their traditions. Separated from other groups by discrimination, they established their own places to meet. Pictured here is the Chinese church in Jackson. They also had three burial grounds in and around Jackson. These cemeteries were abandoned long ago, when all of the remains were removed by fellow Chinese and sent back to China for reburial. (Courtesy Amador County Archives.)

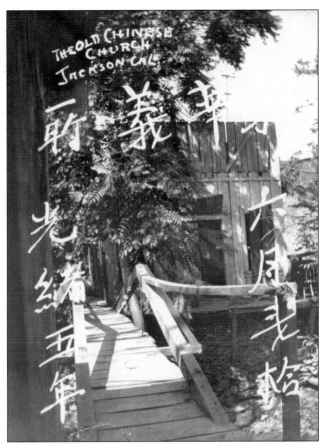

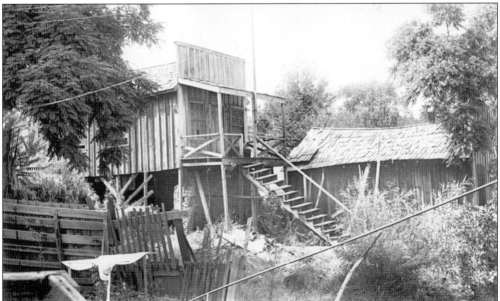

The Chinese also established there own benevolent meeting places. Pictured here is the Chinese Masonic Lodge building that once stood in Jackson. (Courtesy Amador County Archives.)

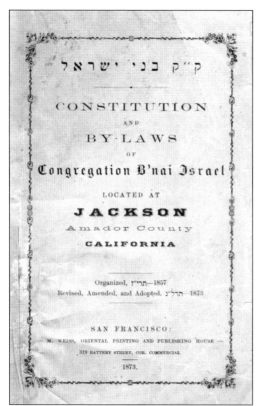

ק"ק בני ישראל

CONSTITUTION
AND
BY-LAWS
OF
Congregation B'nai Israel

LOCATED AT
JACKSON
Amador County
CALIFORNIA

Organized, תרי"ז—1857
Revised, Amended, and Adopted, תרל"ג—1873.

SAN FRANCISCO:
M. WEISS, ORIENTAL PRINTING AND PUBLISHING HOUSE —
319 BATTERY STREET, COR. COMMERCIAL

1873.

Many people of Jewish heritage settled in Jackson in the early days of the town. Men such as John Levinsky, Herman Goldner, and George Durham became prominent members of the community. As early as 1856, the Jews in Jackson established a religious community. Then, in 1857, they erected a *bet t'filah,* or synagogue, wherein they could meet and worship. The building stood on the lot that the elementary school now occupies. In 1869, the synagogue was abandoned, and meetings were held in Jackson's Masonic hall. In 1980, the site of Temple B'nai Israel, the first Jewish synagogue built in California, was designated as California Historic Landmark No. 865. (Courtesy Amador County Archives.)

Julius Peiser was one of the early Jewish immigrants to Amador County. Soon after his arrival from Poland, he set up business as a clothier and tailor. (Courtesy Amador County Archives.)

Many French immigrants also settled in Jackson. Pictured here is Emile Pitois with his grandson Whitney. The Pitois family arrived at Jackson in 1854. The patriarch of the clan worked as a gardener and then went on to plant vineyards and to bottle wine. Emile settled on his own farm near Jackson, served on the board of elections, and worked as a correspondent for the *Amador Ledger* well into his eighties. (Courtesy Amador County Archives.)

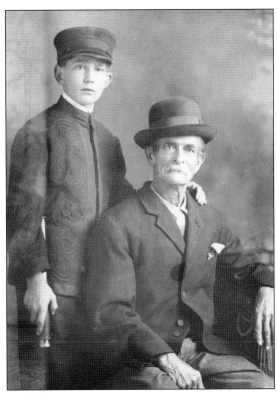

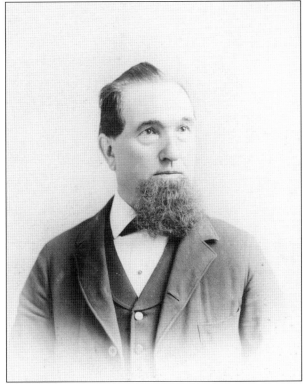

Almost anyone who is a history buff knows the contributions that early Irish immigrants made to the mining industry; however, many also served in public office. Thomas Conlon came to Jackson in the 1850s and soon filled the office of county clerk. He also served as the deputy county assessor, deputy sheriff, and operated a successful insurance and notary-public business in Jackson. (Courtesy Amador County Archives.)

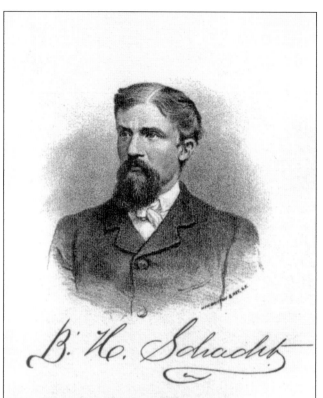

Bruno Schacht was among the many German immigrants who settled in Jackson. Soon after his naturalization, he was elected to the position of public administrator. He was also a physician, a coroner, and a member of the Jackson Brass Band. (Courtesy Amador County Archives.)

Although Scots did not make up a large segment of Jackson's gold-rush population, many of Scottish descent settled here throughout the following decades. In 1979, descendants of these immigrants organized the Mother Lode Scots of Amador County. Based in Jackson, they provide an association for Scots and their descendants, celebrating annual events such as Robert Burns's birthday and the Kirkin' o' the Tartan. (Courtesy Amador County Archives.)

Six

GOLD! GOLD! GOLD!
JACKSON'S MINING INDUSTRY

When miners first came to the forks of Jackson Creek, they dreamed of untold wealth but soon discovered that panning the yellow metal from the streams was backbreaking work. They met with many forms of adversity, from fluctuating water levels that impeded their ability to work to disease and crime. Those early days were precarious, with some simply surviving and others striking it rich. Although many men did succeed at placer mining and managed to find the wealth they were seeking, it was not until the late 19th and early 20th century, when the boom in hard-rock mining occurred, that untold fortunes were taken from the earth.

In Jackson, a number of mines were opened up, of which the most well-known are the Argonaut and the Kennedy. However, many of the smaller underground mines in and around Jackson produced substantial amounts of ore, which provided their owners and investors with affluent lifestyles. Likewise, investors in the mines made money on a larger scale. But it was the miners, those men who went down into the mine 24 hours every day, seven days a week, who are the real heroes of the story. They are the people who brought the wealth out of the ground and, in many instances, gave their lives doing so. Working for meager wages in the early days, they continued on in abhorrent conditions working at thankless tasks. Over the years, unions were formed, and the conditions and wages for the miners improved. Despite these steps forward, however, accidents were unavoidable, and many continued to lose their lives. One of the most tragic mining accidents in the history of the United States occurred on Sunday, August 27, 1922, when a fire broke out one mile below the surface in the Argonaut, trapping 47 miners. Despite heroic efforts to put out the fire and save the miners, everyone perished, leaving Jackson and the rest of the world in a state of shock. The mine was closed for a time until repairs were made and the open wound of the losses was scarred over. During World War II, all of the large mines in the country were closed down under presidential order.

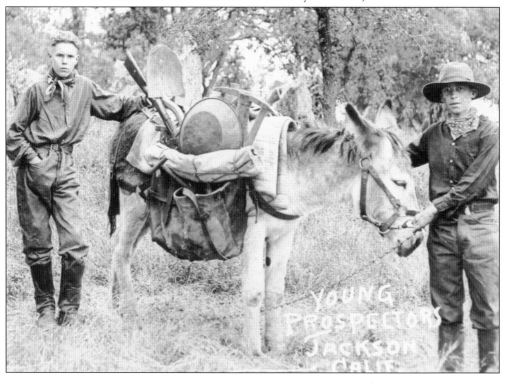

Parody on Byron

The Greenhorns

The greenhorns came down like "the wolf on the fold,"
To the land that was said to be teeming with gold;
And the gleam of their wash pans resembled the stars,
Or the shields of an army, en route for the wars.

Like the leaves of the forest when summer is green,
That host till the month of September were seen;
Like the leaves of the forest when Autumn hath blown
That host in December were scattered & strewn

For the fiend of the Horn spread his wings on the blast,
And the rain at his bidding came sudden and fast;
And the waters were raised, and the prices of grub
Went up like a flash, on account of the bread.

And there lay the tools which they bought upon trust,
Their wash pans and crow bars all covered with rust
And there lay each miner, coiled up in his tent—
His pork-barrel empty—his money all spent.

And the wives of the victims are loud in their wail,
And the merchants and lenders of money turn pale;
And great was the swearing all over the States,
Of those who expected the payment of debts.

For the Banks that once glittered with bright yellow ore,
Discounted the notes of their debtors no more;
And in gulches where once the big chunks did abound,
The "root of all evil" no more could be found.

In vain did they prospect each dreary ravine
In vain they explored, where no white man had been;
The riches they fondly expected to clasp,
Like the will-o'-the-wisp still eluded their grasp.

And the mass of the greenhorns in terror took flight
And returned to their homes in a desperate plight,
Confessed themselves "done most decidedly, brown."

It did not take long for miners to become experienced at their trade. The situation demanded that to live, a person had to learn. The miners who had been in the goldfields for a time had a name for new arrivals: "greenhorns." Around 1850, Charles Boynton, proprietor and editor of the Jackson *Sentinel*, wrote a humorous poem titled "Parody on Byron," more affectionately known in his day as "The Greenhorns." (Courtesy Amador County Archives.)

These two young prospectors and their mule, loaded with their grubstake, give one an idea of what equipment was required for 49ers to work the gravels along the banks of streams and rivers. (Courtesy Amador County Archives.)

Timothy Hinckley, right, was one of those who succeeded in pulling a small fortune out of the earth. However, the twist to his story is that he wasn't looking for gold. Hinckley purchased a parcel just south of Jackson's business district, where he built a home for him and his new bride. On July 3, 1863, while digging a posthole, he encountered a rich vein of gold-bearing quartz about three feet below the surface from which he pulled a total of $60,000 from the claim. Today, a simple iron pipe and old wooden post are all that mark the spot where Hinckley found his wealth. The author is aware of this as an archeologist and because the site now sits in the backyard of her daughter's home. The photograph below was taken at the Hinckley home about 1864. (Courtesy Amador County Archives.)

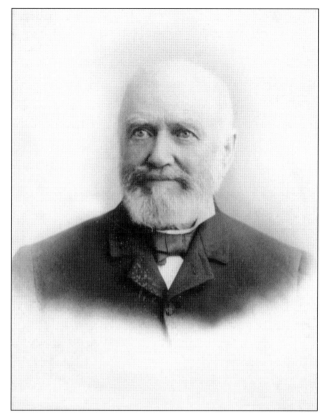

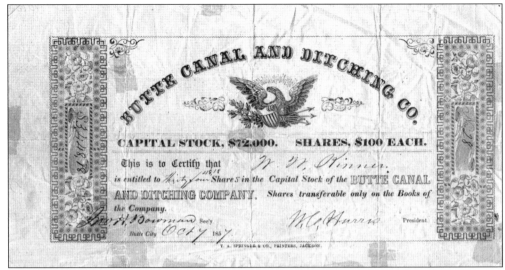

Placer mining required the use of water to wash gold from the gravels. Many miners worked far from a water source and thus conveyance systems were required to transport it to their claims. Capital to fund the construction of ditches and flumes was often raised by forming a company and selling shares of stock. Pictured here is an 1857 stock certificate for the Butte Canal and Ditching Company. (Courtesy Amador County Archives.)

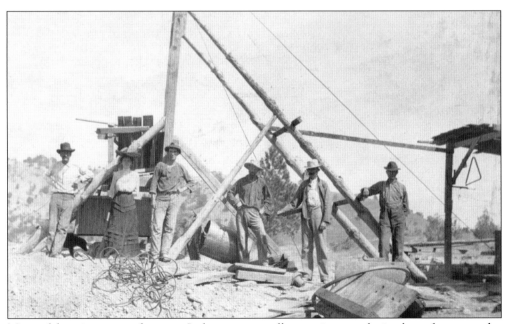

Many of the mines opened up near Jackson were small operations employing but a few men, who in most instances were partners in the undertaking. Here a group poses at the Stewart Mine at Butte City. (Courtesy Amador County Archives.)

With the boom in hard-rock mining, the use of all manner and mass of machinery was developed to remove the ore from the earth and process the material. The grandeur of the head frame at the Kennedy Mine dwarfs the miners standing underneath. This photograph was taken in 1931. (Courtesy Amador County Archives.)

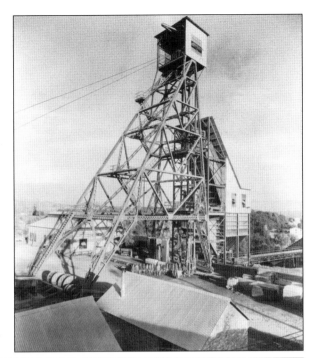

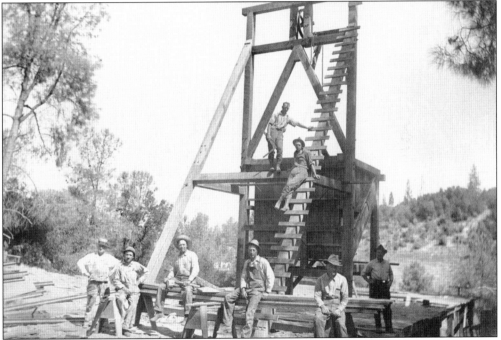

Albert "Powder Face" Moore opened the Moore Mine south of Jackson around 1856. His nickname came from a disfigurement of his face that occurred when explosives he was working with went off prematurely. The mine was operated off and on into the 20th century. This photograph was taken in 1932. Pictured standing from right to left are H. G. Perry, J. L. Irland, G. V. Schacht, J. W. Love, and C. MacKenney. E. R. Santifero is standing on the headframe, and G. F. Pickering is sitting on the ladder. (Courtesy Amador County Archives.)

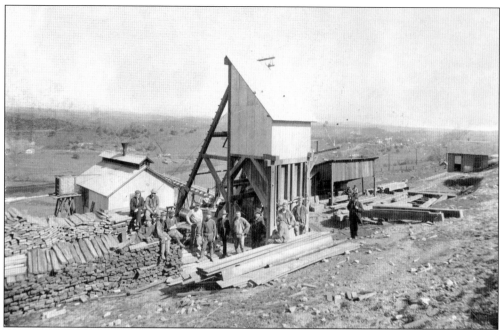

This image shows the Muldoon Mine overlooking the town of Jackson, which can be seen off in the distance. The Muldoon was eventually incorporated into the Argonaut Mine holdings and served as the ventilation shaft for their operations. It was still in use when a disastrous fire killed 47 miners at the Argonaut in 1922. (Courtesy Amador County Archives.)

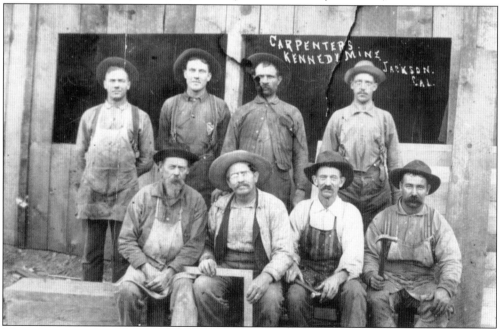

Men of many professions worked at the mines. Seen here about 1893 are a group of carpenters who worked at the Kennedy Mine. Pictured from left to right are the following: (first row) Jonn Tarr, Von ?, ? Jensen, Perry Lepley; (second row) John Gubbins, Humphrey Jones, V. S. Garbarini, Ed Kay. (Courtesy Amador County Archives.)

Men pose at the entrance to the Wildcat Mine, also known as the Madame Pantaloon Mine, which was opened up by Marie Suize. She acquired the moniker of Madame Pantaloon when she donned men's clothing and worked beside them looking for gold. In addition to her mining interests, she partnered in the wine business with Andre Douet, a fellow immigrant from France. (Courtesy Amador County Archives.)

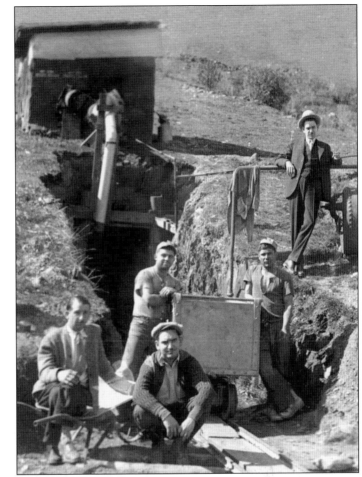

Pictured here is the Jackson Gate Mine, another small operation that was located north of Jackson, near the settlement of Jackson Gate. (Courtesy Amador County Archives.)

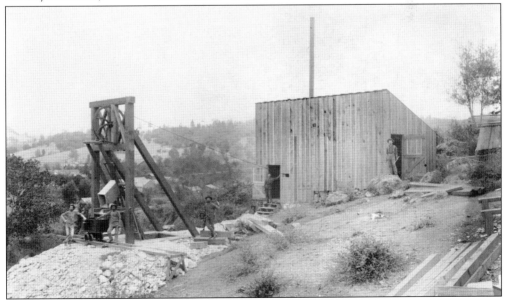

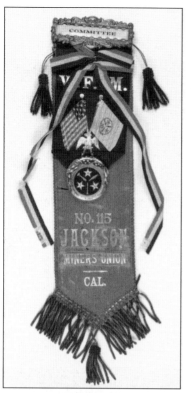

With the growth of underground quartz mining, wages became an issue for the men working long hours for low pay. In 1891, a miner's strike took place in Amador County, and it resulted in the closing of all the large mines. Organizations like the Miner's League eventually organized into unions. This ribbon was worn by a committee member for the Miner's Union in Jackson. (Courtesy Amador County Archives.)

These unidentified miners pose with another man, probably a shift boss, in their underground work area. For many years, miners worked in unhealthy conditions. Many men contracted silicosis, or "miner's lung," from the use of air drills against the hard rock. Dust thrown off by the drills deposited in their lungs, which often resulted in death. (Courtesy Amador County Archives.)

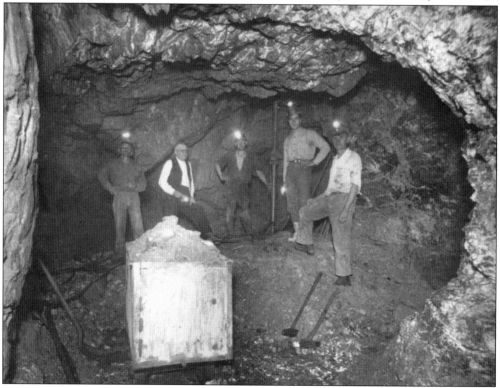

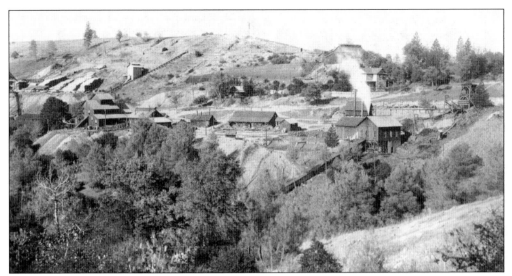

The Kennedy Mine had its beginnings when Andrew Kennedy and four partners staked out a claim on January 1, 1856. The mine was worked until 1942, when it was closed down by presidential order. Today the mine is operated as an historic site by the Kennedy Mine Foundation. Foundation volunteers conduct tours over the Kennedy property from May through October. The Kennedy, and its neighboring Argonaut Mine, has been designated California Historic Landmark No. 786. (Courtesy Amador County Archives.)

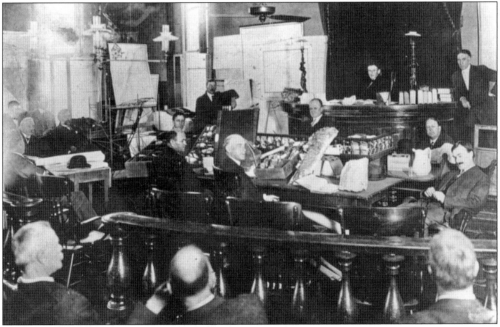

Claim jumping was an issue among miners not only in the early days, but between the larger mines as well. Pictured here, superior court judge Fred V. Wood presides over the proceedings at a lawsuit between the Argonaut and Kennedy Mines. The Argonaut sued the Kennedy for the value of ore allegedly taken by the latter from the plaintiff's ground. The dispute was actually over the boundary line between the two mines. The Argonaut prevailed. (Courtesy Amador County Archives.)

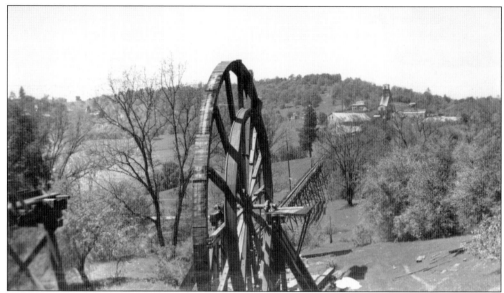

Pictured here are the Kennedy Tailing Wheels, which were used to lift and transport mine waste from the Kennedy and deposit it behind an impoundment dam located a half mile from the mine. These 58-foot-diameter devices moved approximately 850 tons of waste each day from 1914 until 1942. The corrugated iron buildings that once housed the wheels were torn down for scrap when the mine closed in 1942. Today they are the site of a park. (Courtesy Amador County Archives.)

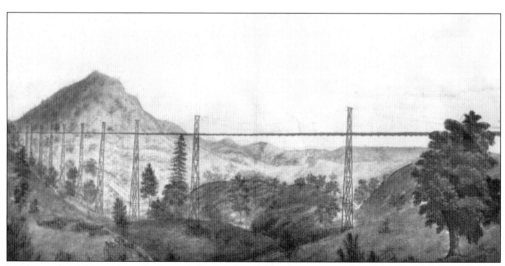

In the early 1850s, miners began to dig ditches to bring water to dry diggings. At first, ditches were short, hand-dug furrows, but as mining operations expanded, larger conveyance systems were built incorporating different components such as canals, flumes, tunnels, and pipelines. Pictured here is a Joseph Lamson watercolor painting of the Tunnel Hill Flume near Butte Mountain. (Courtesy Amador County Archives.)

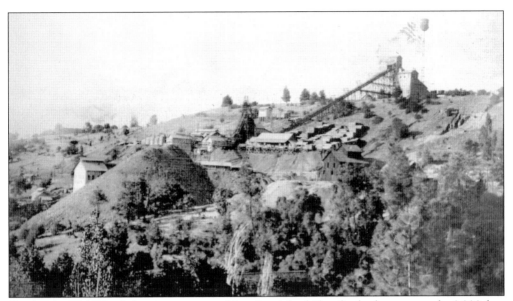

On August 27, 1922, while miners were working the night shift, a fire broke out near the 3,000-foot level in the main shaft of the Argonaut Mine. An immediate attempt was made to put out the fire without success. The flames soon destroyed the wiring in the shaft, disabling the hoist and leaving 47 miners trapped 4,800 feet below the surface. As the fire continued to burn, a rescue effort was launched from the neighboring Kennedy Mine by tunneling between the two shafts. It took 22 days to break through to the Argonaut. Unfortunately, all of the 47 miners perished. When rescuers entered the shaft where the miners lay, they found the message pictured below scrawled on the slate face of the crosscut. The tragedy was broadcast far and wide, resulting in assistance to the miners' families pouring in from around the world. (Courtesy Amador County Archives.)

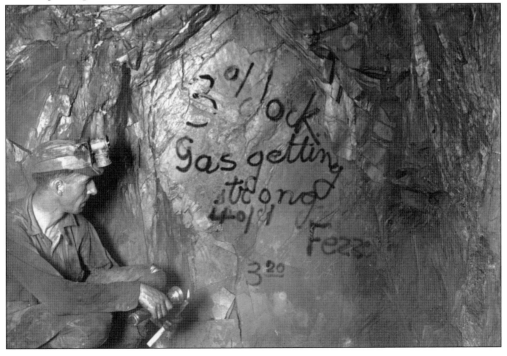

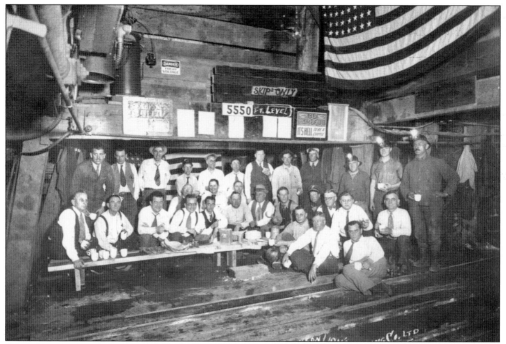

On December 12, 1932, members of the Jackson Lions Club descended to the 5,500-foot level of the Argonaut Mine, where they ate dinner as guests of the Argonaut Mining Company. (Courtesy Amador County Archives.)

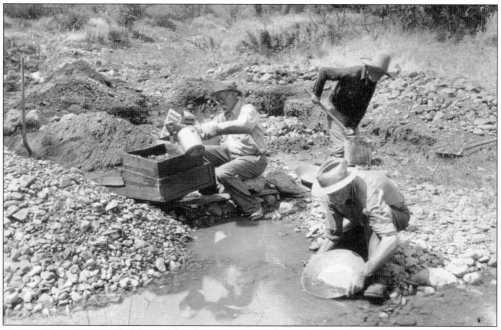

During the early period of the gold rush, miners spent long, backbreaking hours alongside streams and rivers washing the gravel in pans and rockers. In this image, piles of debris that have already been washed surround the miners. Today these piles can be seen along almost any streambed around Jackson. (Courtesy Amador County Archives.)

Seven

PARTIES, POTLUCKS, AND PARADES

ENTERTAINMENT FOR ALL

All work and no play make a town a dull place to live. Greek historian Herodotus once said, "If man insisted on always being serious, and never allowed himself a bit of fun and relaxation, he would go mad or become unstable without knowing it." It seems that the Argonauts took Herodotus's advice to heart. Since the early days in Jackson, when a pet bear was tied to a tree on Main Street to amuse the citizens, entertainment has been a mainstay for the community. Whether it was a stage show, a parade, a private party, or a holiday celebration, generations of Jacksonians have found fun and relaxation.

Just as in any other gold-rush settlement, entertainment in Jackson came in many forms. As early as the 1850s, traveling theatrical troupes visited here with their productions. Another diversion for the miners, which existed well into the 20th century in Jackson, was the women of the red-light district. Saloons were popular places to visit for drinking and gambling, and they often held dances where the miners who were to be the "ladies for the evening" wore scarves on their heads or some other accoutrement to identify them as such. As the camps became settled with more permanent residents, many community groups were formed, such as benevolent organizations, town bands, and baseball teams. Jackson had its own brass band as well as a women's band, established by members of the Native Daughters of the Golden West. The town also hosted a baseball team as did the other towns and settlements in Amador County. Numerous benevolent organizations, such as the Society for California Pioneers, the Native Sons of the Golden West, the Knights of Pythias, the Free and Accepted Masons, and the Oddfellows, all found a home in Jackson. These organizations held potluck dinners, participated in holiday celebrations, and provided cohesiveness to the community.

Today entertainment in the community carries on many of the traditions established during the early days of the town. Annual parades, street fairs, and holiday celebrations are held on Main Street. Little-league and town-based baseball teams come out for games every spring. Dinners are held at the installations for new officers of the benevolent groups. Moviegoers visit the theater north of downtown. And gamblers, no longer able to turn the cards in saloons, play the tables and games at the Jackson Rancheria casino and entertainment center.

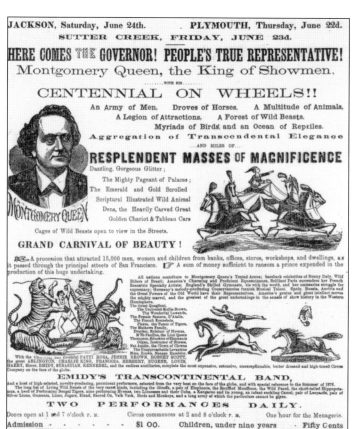

The circus was a very popular form of entertainment during the 19th century. This advertisement, announcing the arrival of Montgomery King's "Centennial on Wheels," was posted in the *Amador Ledger* on June 17, 1876. (Courtesy author.)

Halloween has been a long-standing tradition in Jackson. Here the Jackson Brownies pose in their Halloween finery for the photographer. It seems that clowns, fairies, and wizards never go out of style. (Courtesy Amador County Archives.)

William R. Kay, like his brother Wallace, devoted much time to the aesthetic environment of Jackson. As a member of the Jackson Brass Band, he entertained at many of the town's celebrations. (Courtesy Amador County Archives.)

This 1860 ambrotype of the Jackson Brass Band may have been put together by Wallace Kay, who in addition to being the leader of the band, opened the first permanent daguerreotype studio in Jackson. Although not all of these men are identified, it may be that Wallace, as leader of the band, is in the center. Those known are Frank Hoffman, rancher and liveryman, pictured at the 1:00 position and Armstrong Askey, owner of the Louisiana House, at 7:00. (Courtesy Amador County Archives.)

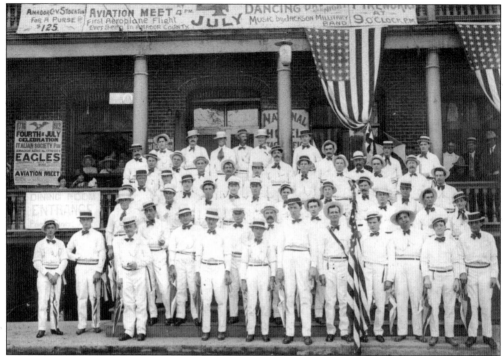

Beginning with the first flight of Orville and Wilbur Wright on December 17, 1903, people became fascinated with the fact that man could actually take off the ground and fly. Once sustained flight was possible, air shows became a popular form of entertainment. In this 1912 image, the Amador Eagles pose on the steps of the National Hotel before a Fourth of July aviation meet. Amadorians were to be treated to the "first ever aeroplane flight ever seen in Amador County." (Courtesy Amador County Archives.)

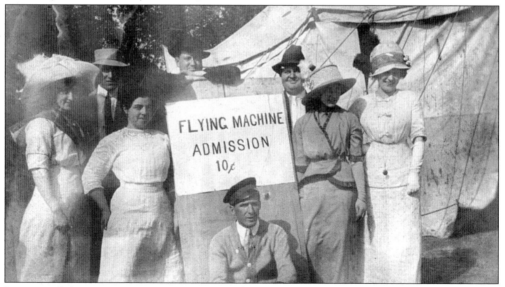

It was much less expensive to get into an air show in the good old days. However, one wonders what type of flying machine this group was waiting to see behind the canvas tent for that price. (Courtesy Amador County Archives.)

Children have always found the celebration of a birthday a momentous occasion. Sierra Lee Summey, pictured here digging into her first birthday cake, is no exception. (Courtesy author.)

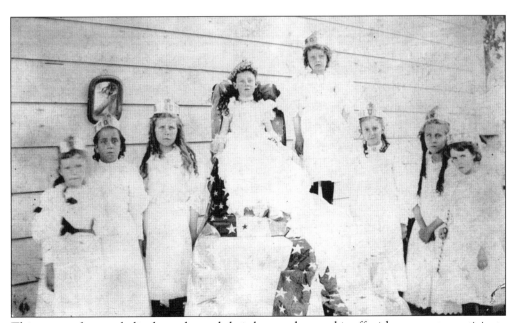

This group of young ladies have donned their best and topped it off with crowns to participate in some type of celebration. Upon examination of their countenances, though, one questions if they are actually having a good time. (Courtesy Amador County Archives.)

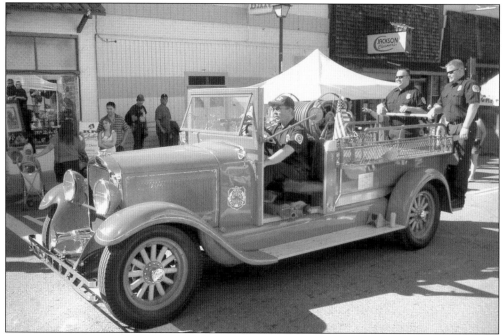

Celebrations on Main Street are a tradition in Jackson. Pictured here are three firemen from the Jackson Volunteer Fire Department handing out plastic fire hats to children during the 2006 Heritage Days celebration. The annual October event, sponsored by the Downtown History Business Association, celebrates Jackson's history and pioneers. (Courtesy author.)

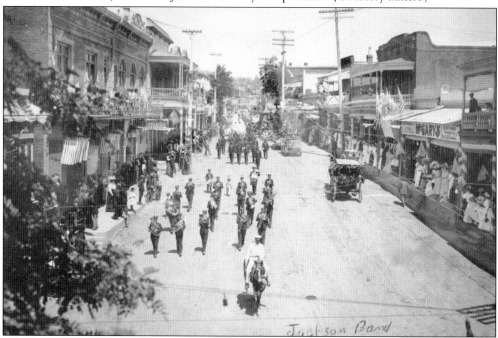

The Jackson City Band leads off the 1909 Fourth of July parade down Main Street. Today large crowds line the sidewalks in Jackson for the annual event just as they did when this image was taken. (Courtesy Amador County Archives.)

Theater has long been a form of entertainment in Jackson. This photograph of the old Amador Theater on Main Street was taken in 1935. Today Jackson's theater, located north of town on Highway 49, offers patrons all of the latest movies on several screens. (Courtesy Amador County Archives.)

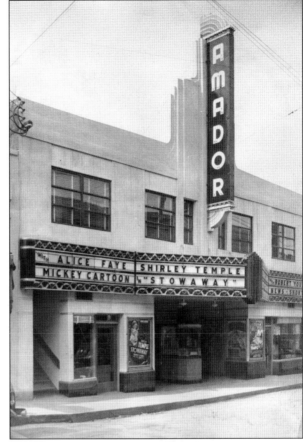

In 1901, the Jackson Kid Band donned blackface to entertain at their venue. Although not politically correct today, many performances by various entertainers were presented in this type of costuming. (Courtesy Amador County Archives.)

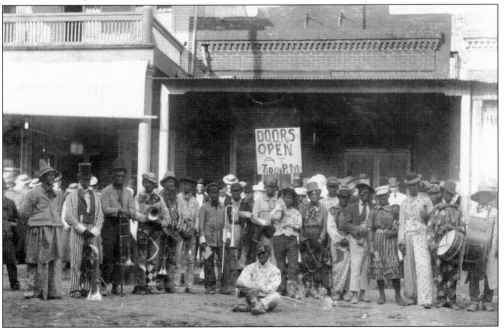

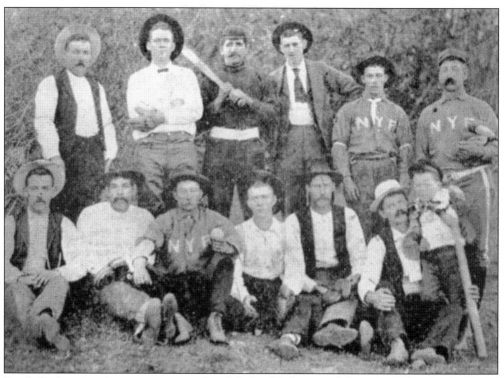

Baseball, the great American pastime, has delighted Jackson and the surrounding settlements for generations. Pictured here is the New York Ranch baseball team, including, from left to right, the following: (first row) ? Trabucco, George Osenfeldt, John Gardner, ? Hambric, Bill McFarland, ? Hanley, an unidentified boy; (second row) ? Bartlett, ? Pickering, L. L. Cuneo, James Spears, Maney Gardner, catcher Charley Harmon. Cuneo managed the team for 14 years. (Courtesy Amador County Archives.)

Boxing matches, always a favorite entertainment for the men, were held in Jackson often. In 1934, World Heavyweight boxing champion Max Baer visited Jackson as a guest referee. The town welcomed him in style, presenting him with a gold nugget to show the appreciation of his Amador fans. (Courtesy Amador County Archives.)

Fraternal organizations have been a part of Jackson's community life for over 100 years. Pictured here are members of the Jackson lodge of the Order of the Knights of Pythias. It was the first fraternal order to be chartered by an act of Congress. The Jackson lodge of the Knights is no longer in existence, having closed many years ago. (Courtesy Amador County Archives.)

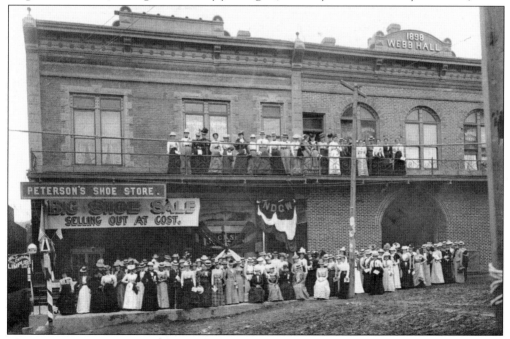

The Native Daughters of the Golden West posed for this photograph at the Webb Building during a gathering in June 1900. Lily O. Reichling founded the organization in Jackson on September 11, 1886. (Courtesy Amador County Archives.)

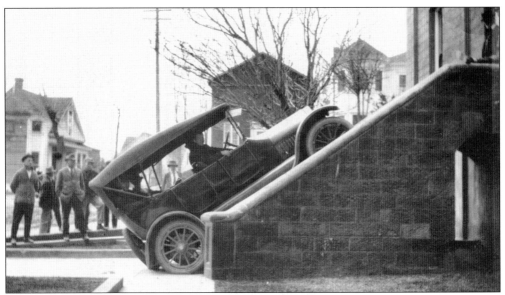

Entertainment comes in all forms. Here locals take their hijinks to the steps of the Amador County Courthouse. (Courtesy Amador County Archives.)

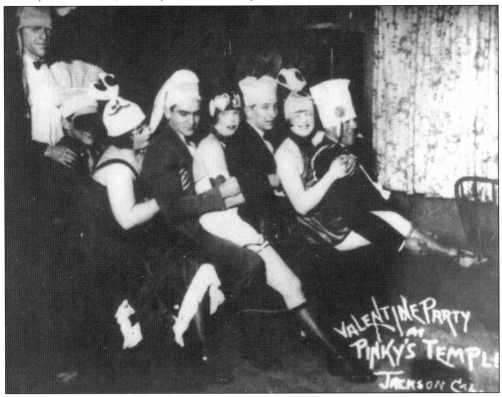

For over 100 years, Jackson had a red-light district. Long after the houses were closed elsewhere in California, they remained in Jackson until 1954, when Gov. Edmund G. Brown closed them down. Pictured here are a group of men celebrating Valentines Day at Pinky's Temple around 1930. (Courtesy Amador County Archives.)

Parades down Main Street draw participants from around the state. Members of the James W. Marshall Placerville chapter of E Clampus Vitus are seen here as passengers in Joe Vicini's fire truck. (Courtesy Amador County Archives.)

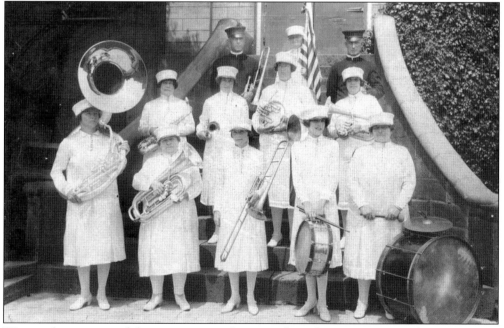

Women also entertained the community with music. The Jackson Women's Band was made up of members of Ursula Parlor No. 1 of the Native Daughters of the Golden West. They are pictured here with Virgilio Belluomini (left) and John Cademartori, who served as conductor and director for the ladies. (Courtesy Amador County Archives.)

Jackson Lodge No. 36 of the International Order of Oddfellows was instituted on March 26, 1855. In 1873, they dedicated their new temple on Main Street, which is the tallest three-story building in California. Pictured here from left to right, at the installation of new officers in 2003, are Deborah Cook-Rice, Tom Minkaer, and Richard Rice. (Courtesy author.)

The National Hotel is always a focal point for Main Street events. This large crowd has gathered to take part in a Red Cross event held in 1920. (Courtesy Amador County Archives.)

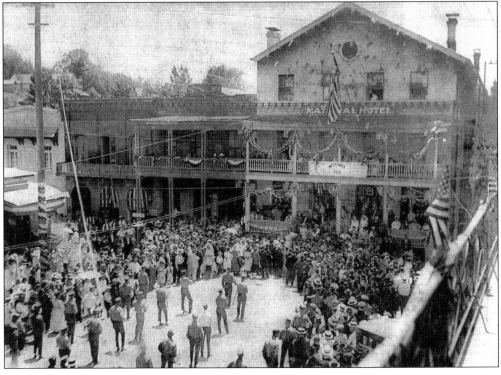

Eight

BEYOND JACKSON
THE SURROUNDING SETTLEMENTS

In 1849, when the Argonauts came looking for gold, they set up camps along streams and rivers up and down the mother lode. Many of these camps grew into thriving business centers. However, many faded into oblivion when the placers were worked out. Still others retained their settlers but never grew to become a town in the strict sense of the word. Several such settlements were established near Jackson, including Butte City, Clinton, Jackson Gate, New York Ranch, Scottsville, Slabtown, and Spanish Town. Slabtown, also known as Hoodville, began as a mining camp but later turned to agriculture. It is in this area that Amador County's viticulture industry began. Although there may have been some mining in and around New York Ranch, it was established early as another agricultural area on the outskirts of Jackson. Kennedy Flat was not far from Jackson, located at the top of the grade just to the north of town. It was probably recognized as more of a "suburb" of Jackson than a separate settlement.

A few of these small communities became ethnic enclaves, and some took on the monikers of their founders. Irishtown no doubt was named for a concentration of immigrants from Ireland, as was Spanish Town, while Jackson Gate became home to many Italian immigrants.

Much of the economy of Jackson was dependent on these small surrounding communities. Profit from the gold that was mined at these locales was spent in Jackson for goods and services. Agricultural products that grew at Butte City, New York Ranch, and Slabtown were sold in town. It was a precarious existence for the small settlements. Some held on longer than others, but most succumbed to the wane of the gold rush. Although they are gone, they are not forgotten. The California Department of Parks and Recreation has designated several of these as California State Historic Landmarks, including Clinton, Irishtown, Butte Store, and Jackson Gate.

In 1851, Butte City was already an established settlement. This receipt from Amos Barrett to William Stewart is for a store located there. Barrett also had a store in Jackson. (Courtesy Amador County Archives.)

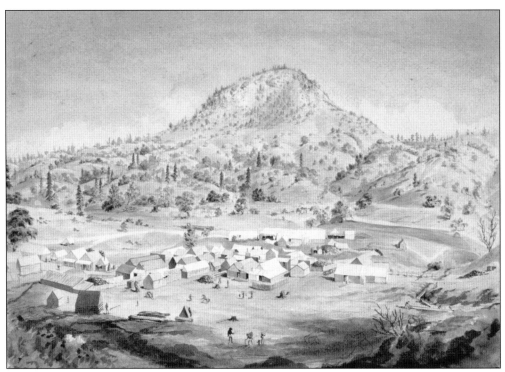

This early 1850s sketch of Butte City offers a view of the settlement with Butte Mountain in the background and gives one an idea of what a booming mining camp it was. (Courtesy Amador County Archives.)

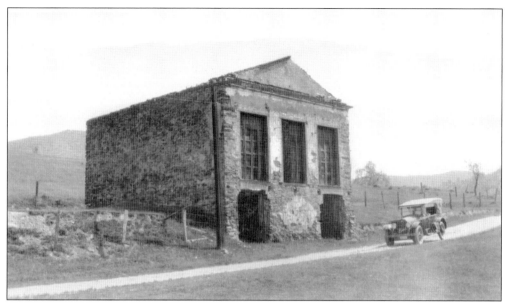

The ruins of the Butte Store are all that remain of the once-thriving mining and agricultural settlement of Butte City. It was first opened by French immigrant Xavier Benoist and later was operated for a number of years by the Ginocchio family. The building is designated California Historic Landmark No. 39. (Courtesy Amador County Archives.)

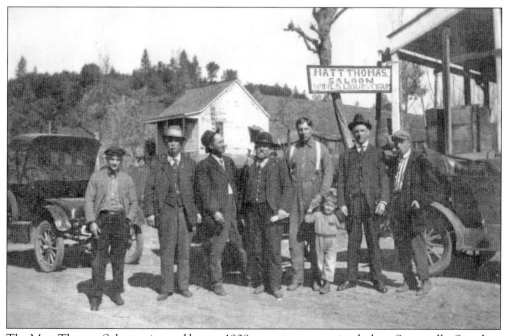

The Matt Thomas Saloon, pictured here c. 1909, was once a watering hole at Scottsville. Standing in front of the saloon are, from left to right, unidentified, Chester Danielson, two unidentified men, proprietor Matt Thomas, unidentified boy, George Thomas, and Bill Oates. (Courtesy Amador County Archives.)

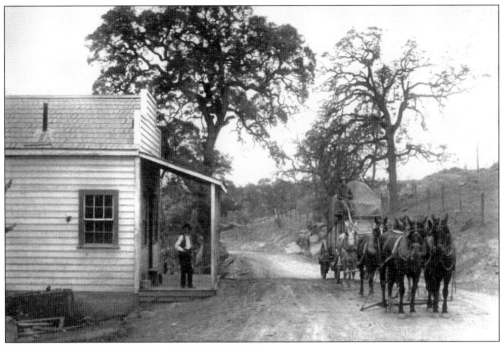

The road from Jackson to Jackson Gate was one of the main thoroughfares to the north, the other being the road up the grade to the Kennedy Mine. The freight wagon pictured here is traveling up the Jackson Gate Road. (Courtesy Amador County Archives.)

In the early days, many roads and bridges charged for passage over them. The cost depended on whether a person was walking, riding a horse, or pulling a wagon with a team. Pictured here is a tollhouse near Jackson that may have been on the Vogan Toll Road. (Courtesy Amador County Archives.)

Elmer Hill Bartlett was born in Slabtown on June 26, 1868. He evidently was fascinated with the mining that went on around him as a child, for as a man he became a mineralogist. Elmer's father, Simeon Bartlett, was a rancher at Slabtown. (Courtesy Amador County Archives.)

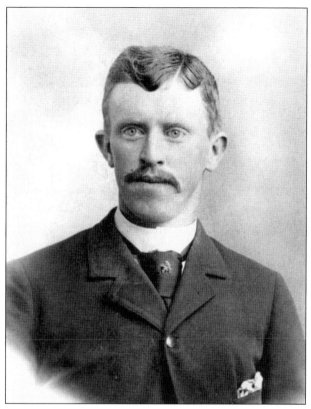

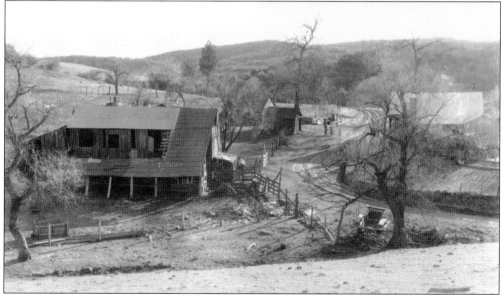

This early-20th-century photograph presents what remains of Slabtown, which was once a thriving mining camp east of Jackson. In 1857, a roving reporter for the local newspaper wrote that there was a substantial business district here, including two grocery stores, a blacksmith shop, a clothing store, three saloons, a tavern, a 10-pin bowling alley, a butcher shop, a dancing hall, and several houses. (Courtesy Amador County Archives.)

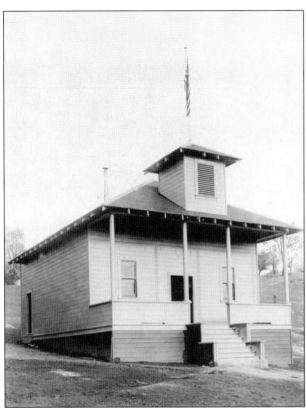

All of the small settlements in the vicinity of Jackson had their own schoolhouse. Pictured here is the Kennedy Flat School. (Courtesy Amador County Archives.)

Today a rest stop is located at Kennedy Flat, where the visitor can pull off the highway and take in the scenery. The kiosk pictured here offers a guide to the landmarks around Jackson. This photograph, taken during a rare snowfall during late winter 2006, also gives a glimpse of the Kennedy Mine head frame, to the left of the kiosk. (Courtesy author.)

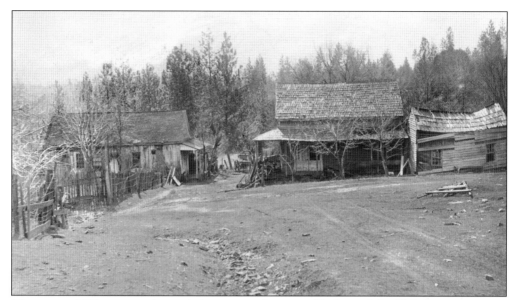

The town of Clinton was located about six miles east of Jackson. Like Slabtown, it grew up around placer mining; quartz mining also took place here as late as the 1880s. The site has been designated California Historic Landmark No. 37. (Courtesy Amador County Archives.)

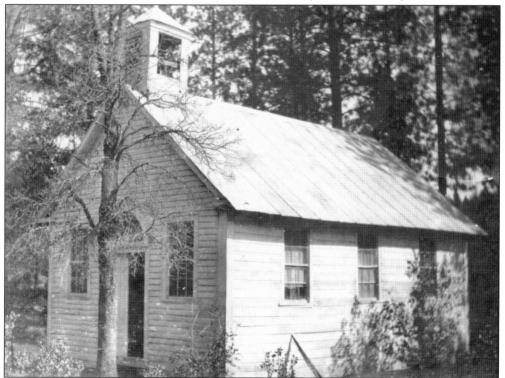

St. Peter and Paul Catholic Church, built around 1877 by Guiseppe Garbarini, once stood at Clinton. In 2003, it was moved to the Kennedy Mine site near Jackson. On June 19, 2005, the Kennedy Mine Foundation rededicated the structure as a historic building. (Courtesy Amador County Archives.)

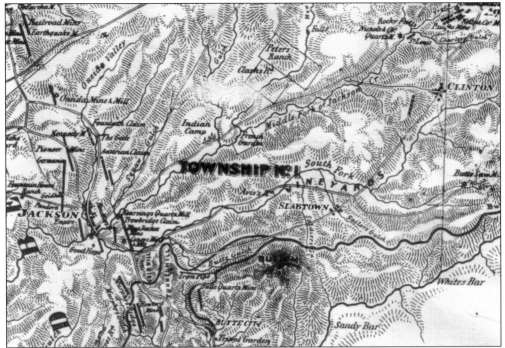

Pictured here is a portion of the 1866 official map of Amador County, showing Jackson and the surrounding area. Note the location of Butte City to the south and Slabtown and Clinton to the east. Jackson Gate, to the north, is labeled simply "The Gate." Many of the quartz mines are also noted, as are the vineyards around Slabtown. (Courtesy author.)

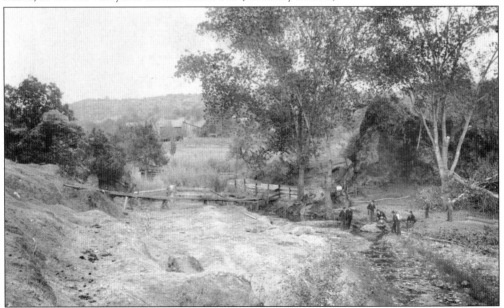

Men try their luck at panning in the north fork of Jackson Creek near Jackson Gate. Note the pipe, cradled in a small wooden flume, on the hillside to the left of the creek. The Jackson Gate Mine was located atop this hill. It is probable that the pipe carried debris from the mine, dumping it into the creek below. (Courtesy Amador County Archives.)

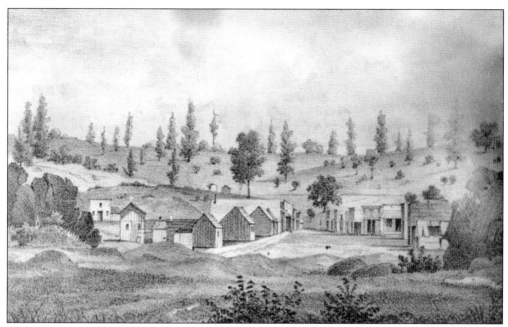

This lithograph of Jackson Gate was produced around 1855. The settlement was home to many Italian immigrants. Among the notable Amador families that lived here were the Caminettis, the Piccardos, the Raggios, the Ghiglieris, the Spinettis, and the Piotoises. In 1850, there were about 500 miners working the placers at The Gate. (Courtesy Amador County Archives.)

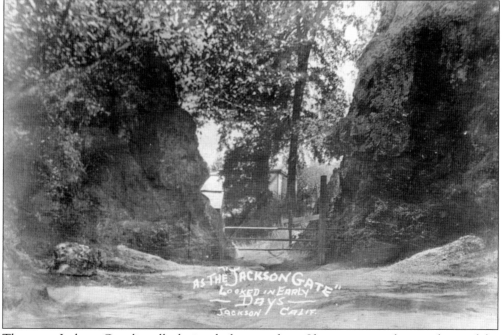

The name Jackson Gate literally depicted what was there. If one were traveling on this road, he or she would have to pass through a gate to get to Jackson. The gate, as expected, was long ago removed, and today a modern paved road passes through the settlement, now considered a suburb of Jackson. (Courtesy Amador County Archives.)

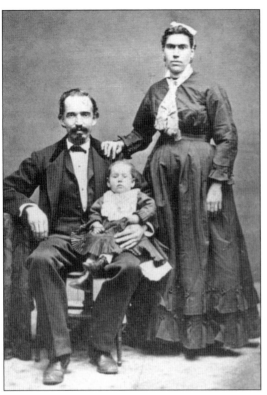

Pictured here are Mr. and Mrs. James Raggio and one of their 13 children, all of whom were born and raised at Jackson Gate. (Courtesy Amador County Archives.)

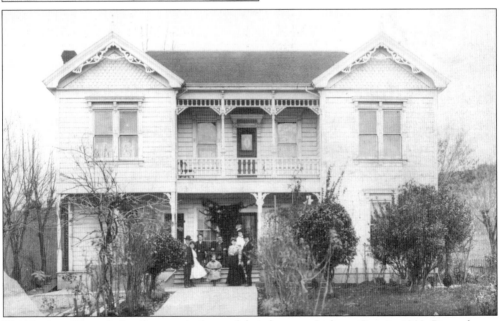

The Andrew Piccardo family poses in front of their home at Jackson Gate in 1902. Piccardo ran one of the early freighting businesses in Amador County. In 1874, he hosted a pork barbecue that was attended by James W. Marshall, the man who started the gold rush with his discovery of the precious metal in the tailrace of John Sutter's lumber mill at Coloma. (Courtesy Amador County Archives.)

The area around Jackson seemed to be the place to produce wine and liquor. Louis Ghiglieri, a longtime resident of Jackson Gate, sold his whiskey under this label. (Courtesy Amador County Archives.)

RICH MELLOW

U. S. STANDARD

WHISKEY

This Whiskey is the highest grade of Kentucky Distillation

SELECTED GRAIN

Louis Ghigliere

Jackson Gate Cal.

The three-story Cosmopolitan Hotel at Jackson Gate, operated by the Ghiglieri family, was for many years a boarding house for miners, until the mines were closed in World War II. It accommodated an average of 18 miners, 2 to a room, at a cost of $1 per day for room and board, which included a packed lunch bucket. (Courtesy Amador County Archives.)

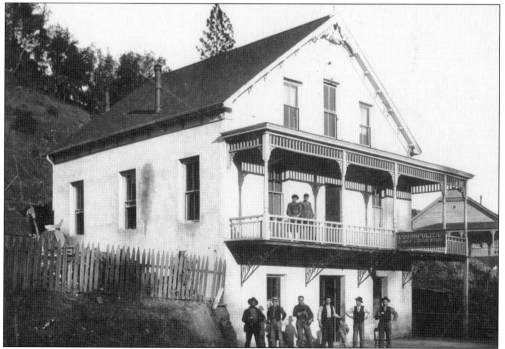

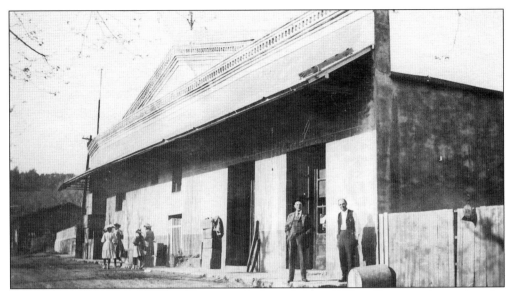

Augustine Chichizola opened his first store at Jackson Gate in 1850 and later another at Amador City. Here he married and raised a family four boys and four girls. Two of the sons, Tom and Julius, oversaw the store at Amador City. Julius then went on to become the president of the Bank of Amador County. This photograph of the Jackson Gate Store was taken around 1900. (Courtesy Amador County Archives.)

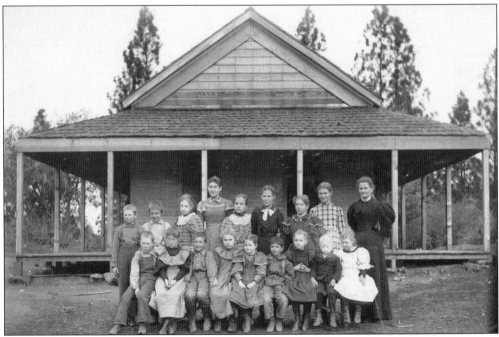

New York Ranch, for the most part, was an agricultural settlement. However, the population was such that a school was needed for the children. In this photograph, students pose in front of the New York Ranch schoolhouse with teacher Kate Spray (far right). (Courtesy Amador County Archives.)

Nine

AMONG HILL AND DALE
AGRICULTURE AROUND JACKSON

In 1849, at the beginning of the gold rush, the majority of those flocking to California did so with the intent of mining, while others saw a need to provide goods and services. Many set up shops providing tools, household goods, clothing, and other supplies. However, during those first few years, a good portion of the agricultural products consumed in the goldfields were brought in from San Francisco, Sacramento, and Stockton, with the exception of limited amounts supplied by a few small vegetable gardens and local ranches raising livestock. Much of the beef, pork, and other meats brought into Jackson came from ranches located near Placerville and Sloughhouse. In 1850, Ellis Evans brought beef into Jackson from the Cosumnes River area, which may have been from Daylor's Ranch at Sloughhouse, and made a sizeable profit.

Although it is generally thought that the gold-rush economy was sustained by mining profits, by 1850, the economy began to diversify. In the area of agriculture, many new species of both plants and animals were brought into California. As with any other industry, the new varieties spread throughout the region. With large tracts of land available, ranches and farms soon went into production. By 1860, nearly 36,000 acres were being cultivated in Amador County, and the livestock being raised was valued at over $750,000. The 1860 federal census enumerated the average size farm in the county at 395 acres.

In the vicinity of Jackson, ranchers raised all types of livestock and crops. These crops included apples, grapes, peaches, plums, prunes, oranges, pomegranates, and figs. Grain crops, such as wheat, barley, rye, and oats, were also grown. Other cash crops included corn, potatoes, and tobacco.

Agriculture in the vicinity of Jackson had its beginnings when Horace Kilham planted a large number of fruit trees and grape vines on his property one mile south of Jackson. Kilham was soon followed by other farmers, such as Quirillo and Company, Constantine Marchal, Andre Douet, Marie Suize, J. B. Milligan, Peter Ferrari, and Simeon Bartlett, who planted farms in the vicinity of Jackson. Other agriculturalists entered raised livestock, ran dairies, and produced wool.

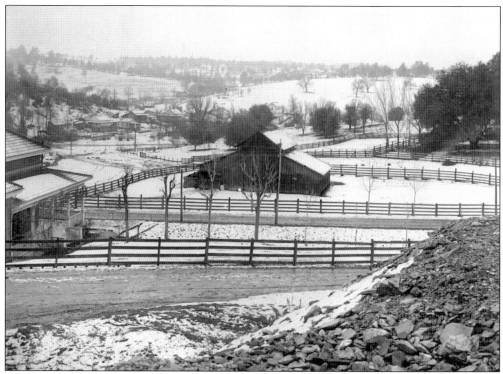

This photograph, taken south of Jackson, gives a view of the rural landscape that surrounds the town. At left is the office for the Zeile Mine. The road in the foreground was the main route to Mokelumne Hill. (Courtesy Amador County Archives.)

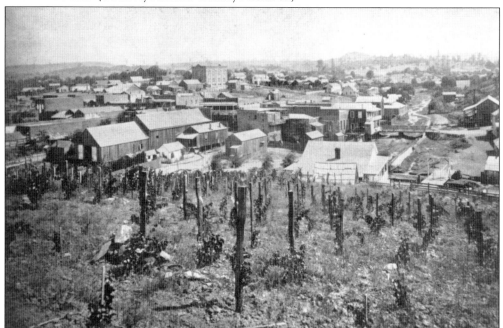

In 1870, when this image was taken, vineyards grew immediately adjacent to downtown Jackson. Today this hillside is covered with homes. (Courtesy Amador County Archives.)

Batiste Previtali emigrated from Lombardy, Italy, in 1889. He soon moved onto a 400-acre piece of land situated between Jackson and Clinton. Within 20 years, Batiste, with the help of his sons, planted over 100 acres of orchards and 200 acres of wine and table grapes. Pictured at right is Sylvio Previtali plowing a vineyard at the ranch around 1922. (Courtesy Amador County Archives.)

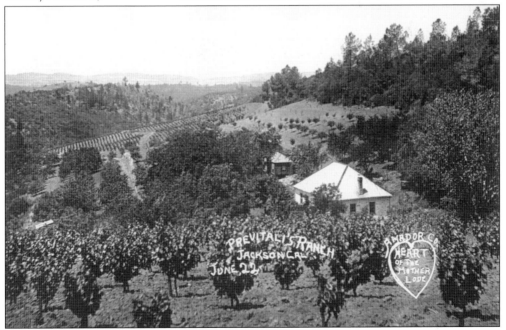

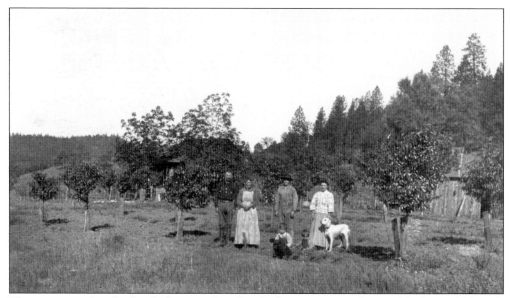

This scene typifies the family farms with orchards that once existed around Jackson. Although many families still live in the rural area around the town, much acreage has been taken up by development. (Courtesy Amador County Archives.)

The Stewart family lived on this homestead in Butte City. It appears that the livestock kept the grass manicured right up to the front porch. (Courtesy Amador County Archives.)

In 1907, ranchers from Amador and El Dorado Counties formed the Stockmen's Association. The organization, based at Jackson, was established to promote the livestock industry in both counties. Members filed their livestock brands with the organization. Pictured here are the cattle brand and earmarks used by Peter Ferarri. (Courtesy Amador County Archives.)

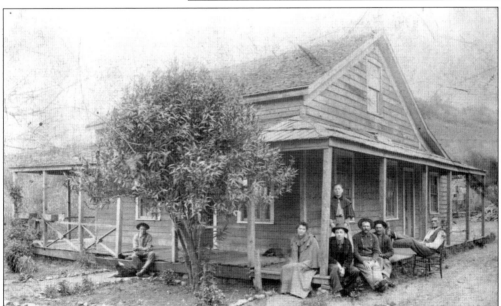

The Ferrari family first settled on a farm at Slabtown in 1859, raising vegetables they sold in Jackson. After a brief stint in the freighting business, they purchased 400-acre tract of land at Butte City, where they cultivated grapes and fruit and raised livestock. This is a c. 1900 photograph of the family taken at the Butte City Ranch. (Courtesy Amador County Archives.)

Jackson had its share of agricultural oddities. This two-headed calf created quite a sensation when it was born on the nearby Drendell Ranch in 1910. (Courtesy Amador County Archives.)

The Murphys settled on this ranch at Butte City. The structure was included in a historic-building survey conducted by the National Park Service in 1934. Note the windmill used to raise water from the well. (Courtesy Amador County Archives.)

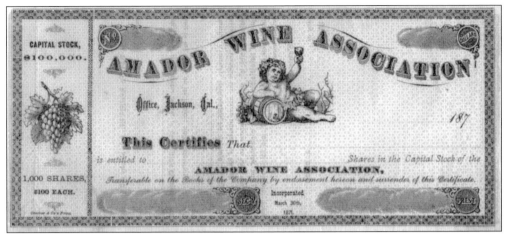

In March 1871, grape growers in Amador County organized and incorporated the Amador Wine Association, opening an office at Jackson. Apparently the group never conducted much business and eventually folded. Today the grape and wine industry makes up a good portion of Amador County's economy and is organized as the Amador Vintner's Association. (Courtesy Amador County Archives.)

This contemporary photograph shows all that is left of the ranch that was known as the "French Garden." In 1863, Andre Douet and Marie Suize took up the property at Secreta, near Slabtown, where they proceeded to plant extensive vineyards and bottle wine. In addition to the wine business, Douet opened up a mine on the property from which he made substantial profits. Marie became known as "Madame Pantaloon," a name assigned to her for her habit of wearing men's clothing and working beside them mining. (Courtesy Amador County Archives.)

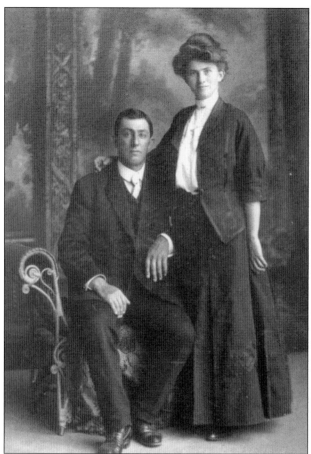

Pictured here are Albert and Alma Diebold Arata, who once operated a successful produce business in Jackson. The Aratas began selling produce in the 1920s out of a barn east of Jackson. They later moved their business to another barn south of Jackson at the corner of French Bar Road and Highway 49, where they expanded the enterprise, adding a grocery store, slot machines, a jukebox, and a dance floor. (Courtesy Ed Arata.)

The Arata barn once stood at the corner of French Bar Road and Highway 49. As with many early landmarks, it has been replaced by modern development. Today the site is the location of a Taco Bell restaurant. (Courtesy Ed Arata.)

Pictured here is an advertisement from a local Amador newspaper when the Arata business was located south of Jackson. (Courtesy Ed Arata.)

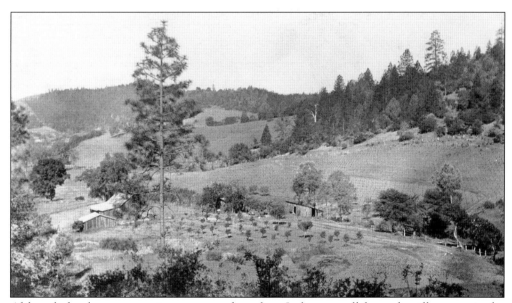

Although development continues to spread out from Jackson, small farms do still operate in the area. Many of these sell their fruits, vegetables, and herbs at a local farmers' market that is open during the warm months of the year. (Courtesy Amador County Archives.)

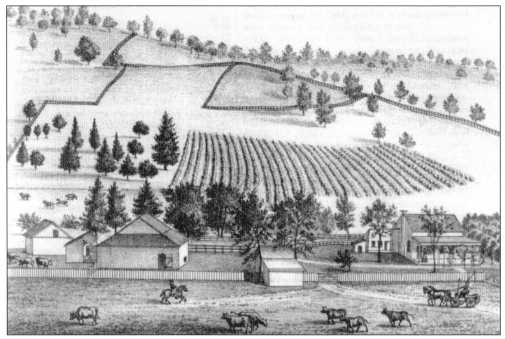

This lithograph from the 1881 *History of Amador County* shows the ranch of M. J. Little, who gave up his interest in mining after discovering that money could be made growing fruit. In 1863, he purchased 168 acres adjoining Jackson, where he planted fruit trees and grape vines. Little found farming very profitable and remained at the ranch until his death. (Courtesy Amador County Archives.)

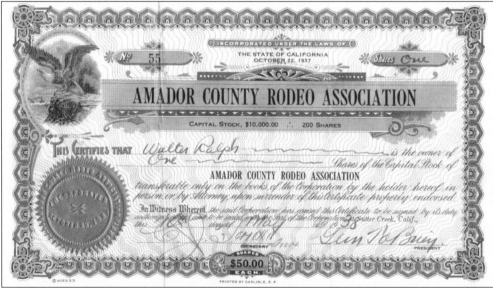

Rodeo is a traditional American sport that has always been a popular form of recreation for those with a rural lifestyle. In 1937, the cowboys of Amador formed a rodeo association based in Jackson. Shares of stock were sold to raise funds for operation and for the promotion and funding of rodeo events. For a time, an annual rodeo was held and the Italian Society Park at Sutter Hill before going to the county fairgrounds, where the tradition continues today. (Courtesy Amador County Archives.)

Ten

INTO THE 20TH CENTURY
TOURISM AND TRADE

Jackson moved into the 20th century at a slow pace that sped up as it moved through the decades. In the early 1900s, the mines were still going strong. The gold coming out of the ground was still the lifeblood of the community, and agriculture was yet a boost to the economy. Jackson was flourishing. In addition to money spent on necessities, gambling establishments, restaurants, and bars did a good trade. During this period is when tourism in the region began to develop. Many new roadside diners and motels opened to accommodate the travelers. Even when the stock market crashed in 1929, Jackson continued on its golden road. Times were good, and the money flowed. However, those golden days were short-lived.

In 1942, all mines in the United States were closed down by presidential order due to World War II. This delivered a severe blow to Jackson. Within a couple of years, though, the town had turned around and was getting back on its feet. Many men who worked in the mining industry found work elsewhere. New industries were developed to replace the lost jobs. During the 1940s, several new buildings were constructed in the central business district, including a Safeway store at the corner of Water Street and Broadway. It was also during this decade that a swimming pool and scout hut were built at Detert Park, near the north end of town.

The town has continued to prosper in the 21st century. Many of the facades of the buildings lining Main Street were updated in the 1920s and 1930s to give the town a modern appearance. Improvements have been made in the public-service sector, and many new businesses have been built. Today Jackson has retained its small-town flavor and has become a favorite destination for tourists. In addition to the attraction of Main Street, the traveler can visit the Amador County Museum or take a walking tour at the Pioneer Cemetery or Kennedy Mine site. Because of the tourism trade, Jackson has once again found its gold.

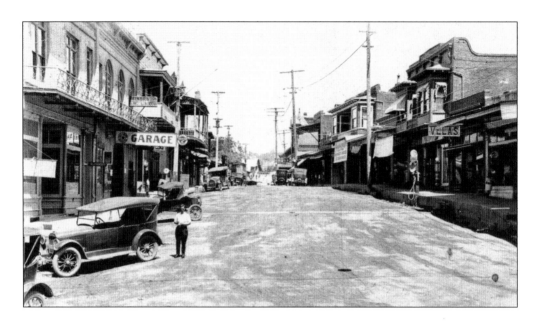

By the 1860s, roads to and from Jackson had been laid out and were maintained by the county, albeit in a minimal way. Many of these thoroughfares were simply wagon tracks into town over which travel was a bit precarious during the winter months. Over the next several decades, improvements to the main roads were made, including realignments and the addition of bridges and culverts. By the 1920s, the automobile was well in use, as can be seen in the image of Main Street (above). In 1921, the road that today is known as Highway 49 was designated the Mother Lode Highway. During the mid-1920s, the California Division of Highways improved the roadway and in the 1930s resurfaced it. This view of the highway just north of the town of Jackson was taken in 1935, when the road was under improvement. (Courtesy Amador County Archives.)

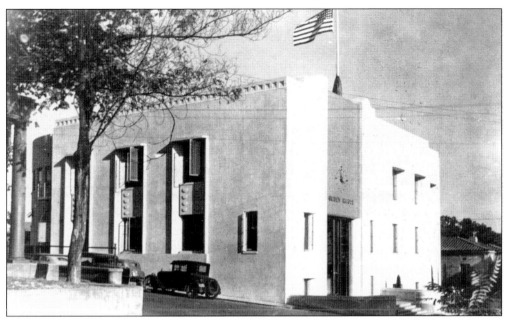

In late 1939 and early 1940, the historic Amador County Courthouse and hall of records were combined into one building and covered with an art-deco exterior. At that time, the courthouse well was sealed and the veteran's memorial plaque that once graced its façade was placed over the well. The building and the plaque were rededicated on June 29, 1940. (Courtesy Amador County Archives.)

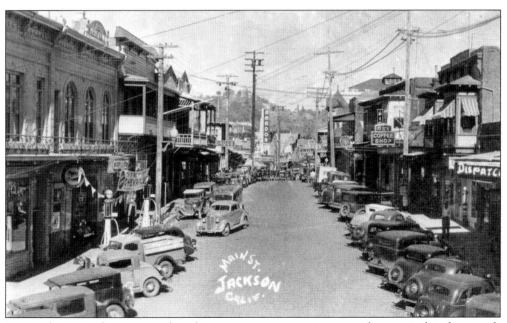

During the 1940s, downtown Jackson businesses were prospering, as can be seen in this photograph taken in 1945. (Courtesy Amador County Archives.)

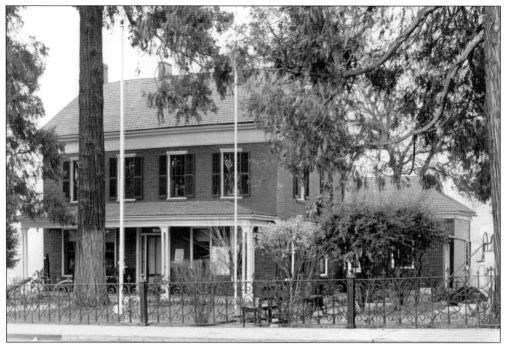

This building has stood overlooking downtown Jackson for over 125 years. In the 19th century, it housed the Armstead Brown family. Today it is the Amador County Museum. Collections in the museum include a wide array of artifacts, paintings, and photographs from Amador's past, as well as a working model of the Kennedy Mine. (Courtesy Amador County Archives.)

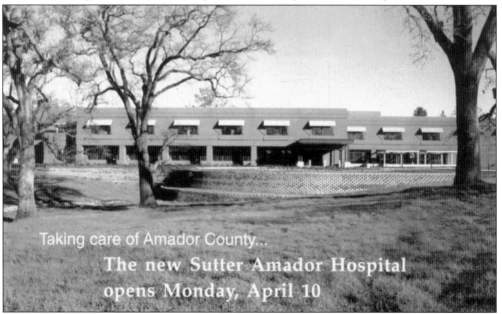

In May 2000, the Sutter Medical Group completed construction on a new hospital at Jackson. The building was dedicated on April 1 of that year, ushering in state-of-the-art medical care for the community. At present, a new wing is being added to the facility. (Courtesy Sutter Amador Hospital.)

As Jackson moves through the 21st century, the county government continues to expand to meet the changing needs of the community. This new County Administration Center was completed and dedicated in 2006. (Courtesy author.)

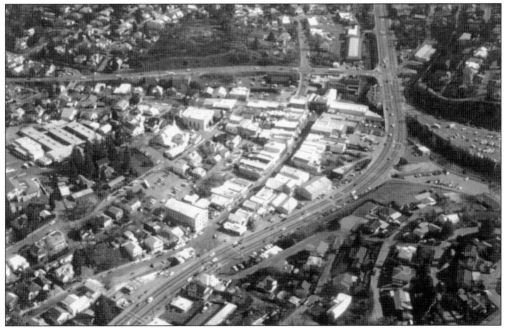

This aerial photograph shows Jackson as it is today. Main Street, once a double row of tents and makeshift lean-tos, is now the center of a thriving foothill community, constantly growing and redefining itself to keep pace with the fast-changing world. (Courtesy Amador County Archives.)

Across America, People are Discovering Something Wonderful. Their Heritage.

Arcadia Publishing is the leading local history publisher in the United States. With more than 3,000 titles in print and hundreds of new titles released every year, Arcadia has extensive specialized experience chronicling the history of communities and celebrating America's hidden stories, bringing to life the people, places, and events from the past. To discover the history of other communities across the nation, please visit:

www.arcadiapublishing.com

Customized search tools allow you to find regional history books about the town where you grew up, the cities where your friends and family live, the town where your parents met, or even that retirement spot you've been dreaming about.